India
a different perspective

Amulya Gurtu

Revised and updated (August 2011)
Revised and updated (October 2012)
Revised and updated (October 2017)

www.facebook.com/India.A.different.perspective

Available at: www.createspace.com/3512915

Copyright © 2011 Amulya Gurtu
All rights reserved.
ISBN: 1456415859
ISBN-13: 978-1456415853

Dedicated to my parents:

Anuradha Gurtu & Gopal K Gurtu

Preface

It all started from the very beginning of my coming to North America. People in North America asked many questions about India, Indian culture, and many intriguing topics about India. I used to explain about its genesis, history, and current reality and people usually used a common expression at the end of the discussions: "aha". These discussions were unplanned, unstructured, and spontaneous, based on my knowledge, experience, and heritage in India. On many occasions, I researched the topic and went back to communicate the complete picture to these inquisitive people. Sometimes, I made sketches, graphs, pictures, and a few slides to communicate my thoughts and facilitate the discussions. On weekends, I shared most of these discussions with my better half Neeta, who, at one point, suggested I write it down for the benefit of our children, who, by their growing up in North America, have limited exposure to Indian culture. It was sometime in 2006 when I

started writing it down. One day, we were going over the notes and Neeta suggested the idea of publishing it for the benefit of people in North America, who are eager to know about India. I started refining my discussions, which are in the form of small essays on a topic and converted over four years of writing. Finally, it turned out to be a book.

Therefore, this is a collection of various discussions I had with many people, regarding a wide variety of topics about India, Indians, and Indian culture, and it is not a book on Indian history.

The Book

This book is for those who wish to acquaint themselves with new things from a neutral perspective about India, without any preconceived notions, based on my analysis, logical reasoning of the topics, and a bit of linkage to the past and sometimes ancient history. I have tried to present the views from the perspective of the current situation and connected the dots with the ancient period, going back thousands of years of civilization in India.

This book presents many points of views that are contrary to popular beliefs about India. This book also discusses many topics related to communities in India as they were or as they are, however, it is not my intention to provide any insights or preferences about any religion or political party. I hold no brief for anyone. It is based on historical facts, written from a neutral and secular perspective.

India – a different perspective

The purpose of this book is to enlighten the people in general in North America, because I realized that people in this part of the world, including the younger generation of a large South East Asian community, have very fragmented and dated knowledge about the Indian subcontinent, India, Indians, and Indian culture. These perceptions are mostly based on hearsay from old times or based on a couple of incidents or sometimes notions without an iota of reality or truth.

Therefore, I hope readers will enjoy the interesting facts about India and get a different perspective after reading this book.

Note to this update

The main difference in this version is in the use of spellings which will help pronouncing the words originated from Sunskrit and Hindi phonetically.

As an example, the correct pronunciation of "Sanskrit" is "Suns-krit". As seen in the first sentence of this note, I am using this spelling instead of "Sanskrit".

Another example involves the removal of an unwanted "a" at the end of Sunskrit and Hindi words. The correct pronunciations of some such commonly mispronounced words include, but not limited to, "yog" for "yoga", "Ashok" for "Ashoka", "Chandragupt" for "Chandragupta", "Shiv" for "Shiva", "Mahabharat" for "Mahabharata", "Keral" for "Kerala", "Arjun for Arjuna" and so on. In short, most of the words written with an "a" at the end of a word derived from Sunskrit or a Hindi are pronounced correctly after removing the ending "a".

India – a different perspective

Another limitation of the languages derived from Sunskrit is the lack of the consonant, "w". British started the use of "w" instead of "v" for words derived from languages in India due to their lack of knowledge of Indian languages. However, Indians continue to use "w" instead of "v" whereas Susnskrit and Hindi have only "v". Consequently, Indians pronounce "w" as "v". Therefore, I replaced "w" with "v" to ensure correct pronunciation of words. For example, "pawan" or "bhawan" is pronounced correctly when written as "pavan" or "bhavan".

English too has many limitations as a language. Unlike Sunskrit-based languages, English does not have many consonants. For example, there is no consonant to make the sound of "the". The closest consonant in English is "d", which is also present in languages derived from Sunskrit languages. An example of this is the pronunciation of Diwali. The correct pronunciation is "thee-va-li".

Acknowledgements

Many people have contributed to completing this book. I thank all the people who have shared their understanding about a topic or asked me to address a few topics I did not initially cover all the topic. Based on the feedback from the readers of the first edition of the book and their desire to learn more about those topics, I have covered them in the subsequent edition of this book.

I would like to take this opportunity to mention the names of two most important people who have mentored, supported, and helped me refine and complete this work. I am indebted to my father Pt. Gopal Krishna Gurtu, who lives in India and spent a lot of time improving my understanding of many topics, which we discussed over the phone, through letters, and emails. I must also mention my wife Neeta Gurtu for encouraging me to start this work without whose inspiration and encouragement I would have never begun.

India – a different perspective

Credit also goes to my daughters who allowed me to spend time with my manuscript in the evenings, during vacations, on weekends and who, besides their editorials, kept motivating me to complete this book sooner.

Last but not the least, I want to thank Ronald L. Donaghe, the winner of the JP Duggins "Outstanding Mid-Career Novelist" Award, 2008, for final editing, proofreading, and providing very encouraging feedback on my work.

Table of Contents

Preface	v
The Book	vii
Note to this update	ix
Acknowledgements	xi
Table of Contents	xiii
Landscape	17
Arranged Marriage	30
Aryan Invasion Theory	42
Caste System	45
Child Marriage	60
Colonial India	65
Corruption	71
Crime on Women	79
Dates, Calendar, and Time	84
Dot	89
Eating with the Hand	92
Eco-Friendliness	95
Education System	102
Female Children - Privileges	126
Food	131
Greetings	139

Grown-up Children Stay with Parents..........142
Idol Worshiping..149
Medical System ...155
Origin of Religions ..165
Parents and Children's Education173
Poor and Rich..177
Religious Harmony ...181
Sati ..190
Secularism...197
Sex ..204
Snake Charmers...209
Students in School..213
Talent Pool ..217
Untouchables..220
Women in the Workforce228
Women's Privileges234
Worshiping Plants & Trees248
Epilogue ..251

India

a different perspective

India – a different perspective

Landscape

India is an ancient civilization with thousands of years of history. This civilization was one of the most developed civilizations at one time in the world. It has been through many ups and downs during its existence and has undergone many changes over the centuries. Therefore, before I dwell on specifics, let us understand the landscape of the present day India, which I will be talking about.

India had been a source of inspiration from the ancient times, and people from far off places in the world had been voyaging for centuries in search of this amazingly beautiful country.

In relatively recent times, for an ancient country like India, an Italian explorer, Christopher Columbus (Circa October 31, 1451–May 20, 1506) began his journey in search of India and discovered America, but he mistook America for India and Native Americans for Indians. Sometimes later, a Portuguese explorer, Vasco

India – a different perspective

da Gama, (Circa 1460–December 24, 1524) started his journey and discovered India by the sea route in the 15th century.

India got independence from British rule on August 15, 1947. Before this day, Pakistan, Bangladesh, and Tibet had been integral parts of India, and people from various religious beliefs were living in harmony and peace. At the time of Independence, Pakistan was created on the East and the West sides of India as one Muslim nation. In 1971, East Pakistan became an independent nation as Bangladesh. The reason behind the creation of Pakistan (today's Pakistan and Bangladesh) was a group of leaders who did not like the idea of becoming a secular country. People from many religions who believed in secularism stayed in India and developed it as the biggest democratic and the largest secular country on the planet Earth. People living in India are blessed to be living in a truly secular country, where government offices, banks, and schools observe holidays for Hindu (*Divali* – pronounced as thee-va-li),

India – a different perspective

Muslim (*Id-ul-fitar* and *Id-ul-zuha*), Christian (Christmas and Good Friday), and other religions. Everyone is allowed to practice his or her religious faith and taught to respect to other religions.

India is also known as Bharat. It is a Secular Democratic Republic. The Constitution of India was adopted by the Constituent Assembly on November 26, 1949 and came into effect on January 26, 1950. The first general elections, under the new constitution, were held during the year 1951-52, and the first elected Parliament came into existence in April 1952.

India has a parliamentary form of the government system. The President of India is the head of the country and the Prime Minister of India is the head of the federal (central) government. The President of India is elected by the Members of Parliament (MP). The President's normal tenure is five years and she/he is also the head of the armed forces, which include the Indian Army, the Indian Navy,

India – a different perspective

and the Indian Air Force. Parliament has a maximum of 545 constituencies each electing one member of the parliament[1], and the members are elected by voting through secret ballot by the citizens of India, both male and female of any religion, who are eighteen years or older. A majority government can work for a maximum period of five years, and then it must go back to the public for seeking a mandate to form and function as a government. The political party with majority seats or a coalition chooses one of the elected members to work as the Prime Minister of India. Similarly, elected members of the state assembly form the state government, and the head of state government is known as Chief Minister (equivalent to a Premier in a province in Canada or a Governor in a state in the USA). The President of India appoints a governor in each state as her/his representative.

India is the seventh largest country in the world, with an area of 1.3 million square miles (3.3

1 http://eci.nic.in/archive/handbook/CANDIDATES/cch1/cch1_1.htm

India – a different perspective

million square kilometers). It has a land border of about 9,444 miles (15,200 kilometers) and the coastline of 4,670 miles (7,516 kilometers). There are twenty-eight states (provinces) and seven union territories in India.[1]

States[2]:
1. Andhra Pradesh
2. Arunachal Pradesh
3. Assam
4. Bihar
5. Chhattisgarh
6. Goa
7. Gujarat
8. Haryana
9. Himachal Pradesh
10. Jammu and Kashmir
11. Jharkhand
12. Karnataka (pronounced as Kur-na-tuk)
13. Keral (pronounced as Ke-ra-l)
14. Madhya Pradesh
15. Maharashtra (pronounced as Ma-ha-rash-tr)
16. Manipur

2 http://india.gov.in/knowindia/state_uts.php

India – a different perspective

17. Meghalaya (pronounced as Me-gha-la-y)
18. Mizoram
19. Nagaland
20. Orissa
21. Punjab (Punn-jab)
22. Rajasthan
23. Sikkim
24. Tamil Nadu
25. Tripura
26. Uttarakhand
27. Uttar Pradesh
28. West Bengal

Union Territories
1. Andaman and Nicobar Islands
2. Chandigarh
3. The Government of NCT of Delhi
4. Dadra and Nagar Haveli
5. Daman and Diu
6. Lakshadweep
7. Puducherry (earlier Pondicherry)

India – a different perspective

The largest state by geographical area is Rajasthan[3], which accounts for 132,139 square miles (342,239 square kilometers), and the largest state by population is Uttar Pradesh[4] (UP), which has a population of 199,581,477.

India's population growth by number is the highest in the world. It is the second-most populated country in the world, with a headcount of about 1.21 billion[5] (2010). This does not include illegal immigrants from neighboring countries. What is the significance of this figure? This number is about 3.5 times the population of the USA and thirty-five times the population of Canada. Now, contrast this figure with the geographical area. India's geographical area is approximately one-third of the area of Canada or the USA. That makes the population density (number of people per unit area) one hundred, twenty times that of Canada and twelve times that of the USA. In simple terms, where one finds a person in Canada, one will find one

3 http://www.rajasthan.gov.in/rajgovt/misc/stateprofile.html
4 http://censusindia.gov.in/2011-prov-results/prov_results_index.html
5 http://censusindia.gov.in/2011-prov-results/indiaatglance.html

hundred, twenty people in India or where one finds a person in the USA, one will find 12 people in India on an average. This magnifies particularly negative things.

Despite such a large population and high population density, India's annual budget is a fraction of the annual budget of the USA. The annual budget (expenditure) of the USA in 2011 was $3.599 trillion (estimated)[6], whereas India's annual budget (expenditure) in 2011 was $0.283 trillion (estimated) only[7]. That is, India's annual budget is approximately one-thirteenth of the budget of the USA, whereas the population of India is about 3.5 times that of the USA. In simple terms, per capita budget of India is about one-fiftieth of the per capita budget of the USA.

India is truly a multicultural, secular, and pluralistic society, where people from many religions coexist peacefully. Hindus form the

6 https://www.cia.gov/library/publications/the-world-factbook
7 https://www.cia.gov/library/publications/the-world-factbook

largest population, but the population of Christians is about 28 million, which is more than the population of Christians in Canada, and the population of Muslims is about 161 million, which is about 4.5 times the population of Canada and about 50 percent of the population of the USA. Besides these three religions, it has been home to followers of many other religions, like Jews, Buddhists, Baha'is, and Zoroastrians etc.

India is the world's fifth largest economy[8]. However, most Indians (71 percent in 2008) live in the countryside (villages), and they are engaged in farming activities. In the USA, 82 percent (2008) of the total population lives in urban areas. The economy of India was predominantly based on agriculture, but now it is changing rapidly. Even though the composition of the economy is changing, the agriculture sector still accounts for 17.2 percent and manufacturing/industry accounts for 26.4 percent of the total GDP in 2011[7]. Comparing

8 https://www.cia.gov/library/publications/the-world-factbook

this with the USA, we find that agriculture is only 1.2 percent, and industry is 19.2 percent in the USA in 2011[9].

India is the world's largest producer of bananas and buffalo milk, the second largest producer of wheat, rice, onions, sugarcane, cashew nuts, tea, and cow's milk, and the third largest producer of potatoes, oranges, and coconuts[10] and the list goes on.

English and Hindi are the only two official languages of India (Constitution of India – Part XVII – Official Language. – Art. 343) same as English and French are the two national languages of Canada. There are many regional languages, but there is no language known as "Indian". English is the only language of the Supreme Court of India and the only common thread between people across India. The language of business is English. Everyone learns at least two languages—English, and one

9 https://www.cia.gov/library/publications/the-world-factbook
10 http://www.fao.org/es/ess/top/commodity.html

India – a different perspective

of the regional languages. If one goes to any place in India, the signboards are typically written in two or three languages—English, Hindi, and/or one of the regional languages, if different from Hindi. All professional education in India is in English. Indians use spellings of the UK English for writing purposes; however, this is changing with the influx of North American organizations. Employees working in the offices of North American organizations in India are switching to using American English. But the education system in India continues to teach the spellings and the rules of grammar of the UK English.

India has a history of peaceful existence for thousands of years and believes in the principle of coexistence with other countries, and religions. India had never attacked any country in its history. However, in just the last sixty years of its independence, India had to face four wars, imposed by its neighboring countries (1962–China; 1965–Pakistan; 1971–Pakistan; 1999–Pakistan). India defended most of its territories

India – a different perspective

but lost a part of Kashmir to Pakistan, Tibet to China and has been looking for a peaceful solution with its neighbors ever since.

India is blessed with phenomenal natural resources and a very varied climate. It has snow- capped mountains with the world's third highest peak Kanchenjunga (28,169 feet or 8,586 meters), lush green valleys, a long coastal line with beautiful beaches, a rich flora and fauna, the great *Gangetic* plains of Ganga and Yamuna with a very fertile land. The Ganga and the Yamuna are among the largest rivers in the world. Besides these two largest rivers of India, there is a network of large rivers like Chambal, Betva, Narbada, Brahmaputra, Sharada, and Godawari spread all over India. The Siachen Glacier boasts of the world's highest helipad, built by Indians and is covered with snow 365 days a year; the world's wettest place is Mawsynram (near Cherrapunji), which is in Meghalaya State in North East India, with an average yearly rainfall of 39.4 feet (12 meters); the world's ninth largest desert, the Thar Desert

(also known as the Great Indian Desert), which is in Rajasthan State in the western part of India. A cricket stadium at a small serene place called Chail in Himachal State is the world's highest cricket playground at 7,500 feet (2,144 meters). The list is endless.

Having briefly discussed the landscape, let us examine some of the topics that keep coming up in the media, causing people to get mixed messages. I had major difficulty in putting these topics in any sequence, or in the order of priority and, hence, I decided to put them in alphabetical order. Therefore, topics covered in the end are equally important.

Arranged Marriage

There are a few aspects of life on which the approach of Indian society is traditional. Arranged marriage is one of these. Marriageable men and women still prefer the involvement of parents, grandparents, and relatives and leave the arrangements of marriage in their hands. This is because India is a society of pluralism, where "we" is considered more important than "I", and "us" carries more weight than "me".

Marriage in India is a socio-religious event, not limited just to the bridegroom and the bride. It is considered a pious ceremony and has been solemnized since olden times in all seriousness and with all sincerity and sobriety. It is an event larger than an individual or a family affair. It is an event of a lifetime for a young couple, standing on the threshold of married life in which relations, community folks, friends, neighbors, and well-wishers are cordially invited to participate and witness the ceremony, bless the

couple, present a token gift, enjoy the celebration, and relish the feast. In the past, the wedding functions (the celebrations and rituals) used to last for days together, but in today's fast-paced lifestyle, the ceremonies are shorter in duration. Everything else remains the same, even today.

Marriage in India is a sacrament and not a contract, as in many other cultures. It is a lifelong union of a man and a woman. Hence, there was no question or provision for separation or divorce among the Hindus since ancient times. Even one stray case of desertion produced shockwaves in the society. The concept of a divorce is a new development, the roots of which can be traced to the last five or six centuries of foreign rules because it was acceptable in their culture. It was introduced in India after independence through legislation, the Hindu Marriage Act 1955. The primary thought underlying the idea of marriage in India was to beget progeny to carry forward the family lineage. The Hindu marriage is said to be for

seven generations, which can be translated in today's scientific language as the DNA of the parents is carried forward by their offspring for seven generations.

In the past, women were free to choose their husbands through a process known as "*swayamvar*" means self-selection of the husband ("*swayamvar*" is a Sanskrit word; "*swayam*," which means self, and "*var*" – pronounced as '*vur*' means bridegroom). The "*swayamvar*" was organized by the father for his daughter to select the most suitable man to be her husband. Once the woman selects the suitable man as her fiancé, the parents made the wedding arrangements. The present-day arranged marriages are a modification of this ancient practice of "*swayamvar*" which, as described later, had to be modified because of foreign attacks, followed by foreign rule, which severely curtailed the freedom previously enjoyed by the young female adults in India. A few examples from the ancient past to present are worth mentioning here.

India – a different perspective

The epic *Ramayan* is considered to be about 10,000 years old. According to this epic, Sita (the daughter of King Janak of Mithila, now in Nepal) had chosen Ram, the son of King Dashrath of Ayodhya, in the state of Uttar Pradesh, India, the most powerful person, through a competitive ceremony (*Swayamvar*). The next example is from *Mahabharat*, which is considered as the biggest epic in the world and is dated about 4,000 years ago. According to *Mahabharat*, Draupadi, daughter of King Drupad of Panchal, in the state of Uttar Pradesh had chosen the best archer, Arjun, son of Kunti and King Pandu of Hasthinapur (near Delhi), through an open competition (*swayamvar*). In a case of modern history in the twelfth century, Sanyogita, the daughter of King Jaichand Rathore of Kannauj in the State of Uttar Pradesh, chose King Prithviraj Chauhan (1168-1192) of Delhi, son of King Someshwar Chauhan of Ajmer in a *Swayamvar*. Another similar case from the early 14th century is that of Rani Padmavati (Padmini), who was the daughter of Gandharvsen and Champavati of

Singhal. She chose King Rawal Ratan Singh of Chittor in a *Swayamvar*.

The active involvement of parents, grandparents, or relations in marriages need not be misinterpreted as "forced" marriage. Also, this is not to suggest that there had not been cases of forced marriages. The point is that, in a country like India, which is multicultural, multi-religious, and vastly diversified, these cases are negligible. Whenever one woman is married against her desire, it is highlighted and blown up out of proportion.

The process of arranged marriage in India follows these steps:
1. Selection of a fiancé
2. Engagement
3. Wedding (sacred ceremonies/rituals called "*Vivah*," similar to tying the nuptial knot), and
4. The start of the married life as husband and wife (known as *Vidai/Gauna* in the Indian context).

India – a different perspective

Parents of the man/woman consult them to seek their readiness for being prepared for marriage and ask for their preferences/choices. If they refuse to be ready for marriage, the parents involve other family members and close relatives in persuading them. They also prepare them for taking up this lifelong responsibility.

They spread the word among the community members and the family priest that there is an eligible person available for the matrimonial alliance in their home.

Community members and the priest suggest the probable matches based on family background, qualifications, job, status, and other qualities of the man or the woman.

Parents shortlist the prospective partners and suggest them to their adult son or daughter for consideration and approval.

In some families and communities, the parents also match the horoscope of the man and the

woman to see the suitability of each, based on Indian astrology, which is an ancient Indian science.

The process of evaluation involves meeting(s) between the man and the woman and talking to each other, at either their residences, or at the residence of a family friend, at a family function, in a social ceremony in the community, or at a restaurant to decide if they approve of each other for the alliance. Sometimes, the man and the woman are introduced to each other without their knowledge of a potential alliance in the future. It is orchestrated so well by the families that the man and the woman generally do not realize for quite some time that the informal meeting was organized by their parents or relatives. These meetings, however, are formal and brief and not as romantic as projected in Indian movies.

Once the man and the woman express their approval for each other and a willingness to marry, the parents of both the man and the

woman start planning for the wedding functions. In some communities, the maternal uncle or maternal grandparents, instead of parents, arrange the wedding, and the entire expenses are borne by them. This ends the process of the first step of marriage, i.e., the selection of a fiancé.

The second step of the marriage process starts with the arrangements for an engagement ceremony, which is pretty much similar as in the West but with lots of fanfare since it is also a social event.

The next major event is the wedding, which is a socio-religious ceremony witnessed by relatives, community members, and friends. It is performed by a Priest (*Pundit*) on a pre-identified auspicious day and time (based on Indian astrology), in front of the holy fire among the chanting of Vedic hymns. Lots of rituals are performed during the ceremony, and the guests enjoy the traditional feast, besides interacting and updating their network. Once the wedding

ceremony is over, the groom returns to his home with family members without the bride. This completes the third step of marriage in India. That is where it is different from the West.

The last step is *Vidai/Gauna* where the groom comes to his in-laws' place and returns with his wife, and they start living together as husband and wife. It is covered in detail later, under "Child Marriage".

Things have changed with time in India, and this change is perceptible in metro cities and big towns. The newspapers are full of matrimonial advertisements, and people make full use of it. Matchmaking bureaus or marriage agencies have been helping people find a suitable match. The latest entrant is the Internet and matrimonial websites. However, there is little difference in taking the help of either newspaper or Internet for marriage purposes. So, there is no need to frown upon one over the other. All serve the same purpose. In the West, this role of introducing two people has been shifted to

common friends, marriage agencies, and matchmaking websites, with parents playing marginal roles due to the changed social circumstances.

To be cautious towards a stranger is not only a part of human nature but is also a prudent step. One wishes to know the background of the other person before establishing any contact with the other. This becomes even more necessary if the contact is going to be a long-term association. The same cautious approach applies in the case of the selection of a suitable candidate for a job by the employer or for the admission to a program by an institution through bio-data, interview, direct transcripts from the institute, background check, credit check, reference check, etc. I do not perceive anything wrong in following the same cautious approach to an event of a lifetime, like marriage, in the selection of a suitable partner. Here we take the help of parents and family elders, common friends, and marriage bureaus.

India – a different perspective

Another new trend, although confined to metro cities only, has come up in which a person directly approaches a potential partner, rather than through parents and family friends. All these options are open and availed in the West also. Here, one may ask why parents and elders are less preferred in the West when they are closely related, more experienced, highly reliable, and the best well-wishers? They are, barring exceptions, the last to suggest or approve inappropriate matches for their loved ones. This is not to rule out the errors on either side in judging a person or his/her family. For that matter, anyone can commit a mistake in selecting someone as one's life partner. But this hardly makes a person any wiser than his or her parents. Whereas parents do have more experience than the person himself/herself. Further, in the case of an unpleasant situation, the young couple can get the support and counseling from their near and dear family members. If we compare these free and nonpartisan services with that of the professionals charging hefty fees for their

services on an hourly basis, I think we will find the former option better. This is not to blame marriage counselors, since they provide a fantastic service, in the absence of any alternative to the society in the West. The only point is, which is a better and more economical option?

India – a different perspective

Aryan Invasion Theory

The greatest misconceived theory about India and the Indians is the "Aryan Invasion Theory". It was propounded in the 19th century by a German Friedrich Max Muller (1823-1900) who settled in Oxford (England).

According to this unfounded theory, Aryans "came from Central Asia to inhabit India after the Indus Valley period. They destroyed the Indus Valley Civilization and settled in India".

The ostensible reason behind this theory was to justify the rulers from outside the border such as Muslim, who came as raiders and, later, the Portuguese, the French, the Danish, the Dutch, and the British, who came as traders and established their rule in India. In simple words of Dr. Navaratna Srinivasa Rajaram, "Germans invented it, British used it". But "modern archaeologists say Aryans were indigenous people who resided mainly along the Sarasvati River. Once it dried up, they migrated to regions

India – a different perspective

within and outside India and also settled in the Indus Valley."[11]

Indians never believed in this theory because it was already established long back in the verses in Manu Smriti as:

"That land, created by the gods, which lies between the two divine rivers Sarasvati and Drishadvati, the (sages) call Brahamaverta". (ii,17)

"The plain of the Kurus, the (country of the) Matsays, Pankalas and Surasenakas, these (form) indeed the country of Brahmrishis (Brahmanical sages, which ranks) immediately after Brahmaverta". (II,19)

"That (country) which (lies) between the Himavat and the Vindhya (mountains) to the east of Prayaga and the west of Vinasana (the place where the river Sarasvati disappears) is called Madhyadesa (the central region)". (II, 21)

[11] The Times of India; November 7, 2010

"But (the track) between those two mountains (just mentioned), which (extend) as far as the eastern and western oceans, the wise call Aryavarta (the country of the Aryans)". (II,22)

"Arya" or "Aryan" does not mean a race or class of people. The word "arya" is a Sanskrit word which means "a noble person". This word had been referred to in many Hindu scriptures which are thousands of years old. The "Aryan Theory" was developed, nurtured, and propagated with the sole objective of dividing Indians among Aryans, and Dravidians and rationalizing the occupation of India by British. The "Aryan Invasion Theory" now stands refuted.

Caste System

The portrayal of the caste system of India is an extremely poor reflection of its original concept and form, and it has never been portrayed as it was originally conceptualized, designed, or practiced. The caste system was never meant nor was a means to segregate people from the mainstream. In very simple terms, the caste system of India was a means of division of labor, according to one's inclination and abilities, which in today's terminology, we call a white-collar and a blue-collar job or categorize the workforce as workers, staff, and executives. The caste system in India was exactly the same.

The caste system was work-based and not a birth-based system, as reflected in a Vedic hymn which says, "I am a poet, my father is a doctor, and mother is a grinder of corn". Further, had the system been birth-based, then *Satyakam Jabala*, who could not provide the name of his father to prove his caste, would not have been accepted by the Sage as his disciple,

and the educated and enlightened Jabala would never have become Sage (*Rishi*) Jabala. Both, *Guru* Dronacharya, a *Brahman* and Prince Drupad, a *Kshatriya*, were taught in the same *gurukul* (ancient Indian residential education institute). Later, *Guru* Dronacharya, who was a *Brahman*, not only taught the science and art of warfare and the use of arms to both Pandav and Kaurav princes but also donned the mantle of Chief of Army (Senapati) and fought from the side of Kaurav against Pandav in *Mahabharat*, which is supposed to be an activity of a *Kshatriya*.

However, the work-based groups or community system underwent a sea change over many centuries, and the reason for it is not far off to seek. It was the onslaught of the attackers and the invaders from across the western border of India. It began with the attacks in Punjab and Gujarat by the Persians (present-day Iran) in about sixth century BC, followed by the armies of Alexander (355 BC–323 BC) invading Punjab (India) around 327 BC–326 BC and others.

India – a different perspective

While some of these raiders plundered India and left the country, others stayed back and ruled. The impeachment of Lord Robert Clive in the British Parliament for plundering Indian wealth is well known to be repeated here. Thomas Babington Macaulay, (October 25, 1800–December 28, 1859) introduced the English language as well as the British education system in India in 1835.

This forced the people to withdraw into their shells like tortoises to convert the work-based division of groups into a birth-based division of groups and into watertight compartments of caste, only to protect and save the expertise and characteristics of each group. With the passage of time, people continued in the same profession for many generations and became experts in their fields. Because of the history of approximately the last eight hundred years of constant mutation of the caste system, it became difficult, but not impossible, to go from one kind of work to another kind of work. This was predominantly due to the insecurity and the

India – a different perspective

uncertainty about the intent of a new person taking the work of a community from another community. The result as conveyed was a narrow and birth-based system of castes.

The British had supported the feudal system created by Muslim rulers for their own interests. They kept this exploitative system alive for the cheap agricultural labor and serfs to until their agricultural lands both in India and in other colonies outside India. Similarly, the religious institutions had their own interests in the continuation of this system and failed to change the mindset and to ameliorate the conditions of the have-nots and the downtrodden.

Erosion of the system and its values had begun after the attacks of Persians. It continued due to the attacks by the armies of Alexander. In the meantime, King Chandragupt Maurya, a contemporary of Alexander, Buddha (623 BC–543 BC), and King Ashok (272 BC–232 BC), the grandson of King Chandragupt Maurya had left the stage. Moreover, the world's two biggest

universities, Takshila and Nalanda, and their libraries, along with records, and manuscripts had been destroyed. When Sage Manu appeared on the scene, damage to the old system had already been done. Sage Manu is said to have transcribed Hindu Laws from the memories of the past, known as *Manu Smriti* (200 BC–200 AD). "*Smriti*" is a Sanskrit word, which means memories. According to the ancient culture, people are categorized into four broad groups based on their profession, and not on their birth:

- *Brahman*
- *Kshatriya*
- *Vaishya*
- *Shudra* (sometimes written as *Sudra*)

Their functions, as described in Manu Smriti, are as follows:

"To *Brahman*s he assigned teaching and studying (the Veda), sacrificing for their own benefit and for others, giving, and accepting (of alms)". (Manu Smriti: I, 88)

"To *Kshatriya*s he commanded to protect the people, to offer sacrifices, to study (the Veda), and to abstain from attaching himself to sensual pleasures." (Manu Smriti: I, 89)

"To Vaisyas to tend cattle, to bestow gifts, to offer sacrifices, to study (the Veda), to trade, to lend money and to cultivate land." (Manu Smriti: I, 90)

Rest of the work was assigned to the people of the last group and these were referred to as *Shudra*s. However, a *Shudra* becomes "worthy of honour" by virtue of his age. (Manu Smriti: II, 137 & 155); The *Shudra* wife of a *Brahman* teacher is given due respect by his student and is "honoured by rising and salutation." (Manu Smriti: II, 210); A *Shudra* can be a pupil as well as a teacher. (Manu Smriti: III, 156); A *Shudra* "may be made witness in law suits." (Manu Smriti: VIII, 63); A *Shudra* can "give evidence". (Manu Smriti: VIII, 68)

India – a different perspective

The education and intellectual activities were considered as the most important activities in the society. The people engaged in these activities were placed at the first position. This group included educationists, priests, astrologers, and medical professionals under this category. These people are known as *Brahman*. Also, the role of people in the community of *Brahman* was limited to intellectual work, like teaching/training, astrology (science), physicians/surgeons, and lawyers, etc. Despite having the excellent knowledge of various subjects, they were not great in doing many things, like conducting business or fighting. They were exceptionally great in imparting knowledge or practicing a few highly skilled jobs, requiring mental work, like medicine. The ancient system of medicines in India required a lot of understanding about astrology, besides human anatomy and medicines. *Ayurved* (*Ayurveda* is incorrect) is the ancient science of medicine in India, requiring an understanding of astrology. Those who teach are called "Gurus." It is different that

nowadays, a teacher may not be a *guru* of the subject, but in its original form, a teacher was supposed to be a *guru* on the subject. They are also called *pundits*, which means they are proficient in several subjects and have mastery over these. The appellation "*pundit*" attached to *Brahman*s is of very late origin, i.e., from the later period, especially after the end of Afghan rule and the beginning of Sikh rule. It was given to those Brahmins who were proficient in Sanskrit besides Persian. It became a common address later on during Muslim period. Incidentally, both the words—*guru* and *pundit*—have found a place in the English Dictionary. The importance of a teacher in the Indian context is considered utmost for the success in both physical as well as the spiritual life of a person. It is echoed in a beautiful couplet by the saint-poet Kabir (Circa 1398 AD– 1518 AD), which is as follows:

"*Guru govind dou khade, kakey lagoon paye.
Balihari guru apno, jin govind deo bataye.*"

The couplet translates as, "The teacher (*Guru*) and the God (Govind) both appear before me at the same time. I am in a fix as to whom I should pay my respects to, first. Then the poet Kabir decides and places the *guru* above God because it is the teacher (*guru*) who showed me the path which led me to the realization of the God." And these gurus were from the *Brahman* community in India. They used to provide education on all subjects, including business, politics and statecraft and not limited to archery and swordsmanship and the use of other weapons only. Compare this with today's system, and you will not find much of a difference.

Kings, warriors, fighters, and soldiers were assigned the next place in the order of the importance of the work because they were entrusted with the responsibility of protecting life and property and to make the society safe and the boundaries of the state secure from the enemies. These were designated as *Kshatriya*. These army men were well built and strong and

India – a different perspective

genetically daring, adventurous, and outdoor people, who had an aptitude for fighting, warfare, and planning war strategies. They spent their time from early childhood learning martial arts (archery, swordsmanship, wrestling, etc.), and the use of weaponry. In olden times, the fastest mode of transportation was the use of trained animals. Hence, these people were adept at riding horses, camels, and elephants for long hours and covering long distances. They were the community of military personnel in India, as in the rest of the world. In today's parlance, they are known as the martial race of India. The people belonging to the third group included vendors, traders, merchants, businessmen, manufacturers, industrialists, and finance and accounts personnel. They had an excellent ability for planning and executing trading and manufacturing activities and doing complex mathematical calculations related to business and accounting. The people of this group were called *Vaishya*. However, the *Brahman* community taught them these skills. Despite having the knowledge of business,

India – a different perspective

*Brahman*s were not good businessmen. Artisans, like carpenters, blacksmiths, goldsmiths, potters, and weavers who are manufacturers, as well as sellers of the handmade items, also formed part of this community. This group also did cultivation and tended cattle.

The rest of the people who formed the grass-root level labor force fulfilled the needs of all by doing work requiring physical labor and were designated as "*Shudra*." They too had an equally important role to play in the social fabric of India whether it was a time of peace or war. These people used to work for all the sections of people in the society, similar to *Kshatriya*s, who used to protect the entire society or *Brahman*s who used to provide medicines to all the sections of the society or *Vaishya*s who produced and sold goods to all. They used to work on farms and in the houses. These people had enormous physical strength and endurance for working long hours. Despite their physical strength, these people were not made part of

India – a different perspective

the *Kshatriya* group because of the lack of an aptitude to fight and kill another human being.

However, all the four groups lived in harmony and peace because each was interdependent on the rest of the three groups.

Dr. B. R. Ambedkar, the chief architect of the Constitution of India, was not from any of the first three groups, yet he played a pivotal role in making the constitution; he was well respected and held in high esteem. He was well read and had many doctorates to his credit. He had his early schooling under a *Brahman*. There are people from each community who join the work in the other three categories, which was limited to the members of a community during the last few centuries.

Three of the Presidents of India, one Chief Justice of India, Speaker of the Parliament, and some of the Central/Chief/State Ministers were not from the so-called upper castes. There are hundreds of thousands of people in India from

the ancient *Shudra* community who hold high-ranking posts and are engaged in the jobs of their choice and inclination. They are becoming educationists, traders, businessmen, and industrialists. Nowadays, *Brahman*s can be seen in trade and in defense services, *Kshatriya*s in education and the medical profession, *Vaishya*s in education, medical, and defense services, and *Shudra*s in education, trade, medical, and administrative services. Independent India is trying to undo the damage done to the social fabric for over centuries of foreign rule.

The word *Brahman* or *Pundit* does not, as such, mean a wealthy or a rich person. It only indicates that the person is well read and knowledgeable, both in worldly as well as spiritual matters and is competent enough to guide others. Knowledge and skill have nothing to do with the earning capacity or accumulating riches. The world's biggest epic *Mahabharat* mentions that Sudama, a *Brahman* and Lord Krishna, a *Kshatriya*, studied together at the

gurukul of Sage Sandipan near Ujjain, Madhya Pradesh yet Sudama lived the life of penury, whereas Lord Krishna had it all.

There were many reasons listed below, which made it harder for anyone to cross the boundaries of these divisions of labor. These are not in the order of priority or importance, because I do not know which was more important then.

- A lack of appreciation from the original community, if someone wanted to take up the profession of the other community.
- The form of teaching was through face-to-face interactions. Books were rare, and computers, and the Internet did not exist. Therefore, it was hard to learn the "tricks of the trade" without living in that environment for a long period of time.
- Customers and consumers did not trust anyone who was a first-generation member of a new profession, which is not hugely different from today's thinking.

India – a different perspective

- Anyone joining a new trade (type of work), will have more pressure for success as compared to a person from a community of the same profession.
- Limited availability of the resources for the new trade.

Despite these barriers, there are cases where people have outperformed and jumped the threshold of the division of labor in the past. After the independence of India in 1947, all the citizens have been given equal rights and opportunities, and there is no discrimination between people, based on their caste, color, religion, or gender under the constitution of India.

Child Marriage

Child marriage was neither sanctioned nor prevalent in ancient India. According to *Ayurved*, a woman is supposed to be physically and mentally ready for motherhood only after she has completed thirty-six normal monthly cycles of menstruation, which would make the marriageable age of a young woman around seventeen to eighteen years. The people, in general, adhered to this norm for entering into matrimonial alliances. Modern medical science also, more or less, agrees with this view for the physical, mental, and psychological well-being of the mother, as well as the health and the safety of the newborn. Now, the legal age of marriage in India for a man is twenty-one years and for a woman, it is eighteen years. Marrying a man or a woman before their respective legal age of marriage is a punishable crime under the constitution of India and invites legal actions.

The system of child marriage in India was, in fact, of late origin. This started sometime after

India – a different perspective

the attacks from across the borders, which forced a rethink in the ancient system of marriages in India. The attackers, wherever they could lay their hands on, abducted girls/women. The young girls/women were sold in the Central Asian Muslim Courts. The concept of child marriage was thus born out of these peculiar, and extraordinary circumstances. It was actually a temporary arrangement in the interest of young girls/women. It was a via media invented during that period to protect the unmarried young women from the attackers. Even during the first war of independence in 1857, British soldiers are reported to have abducted unmarried young women. Therefore, under this arrangement, a girl was wed at a relatively early age with a boy of her age group (generally a couple of years older) in some parts of India. But even after the wedding at this early age, the girl neither started her married life nor stayed with her in-laws or husband. The "married child" remained at her parents' home until she attained the proper marriageable age. These girls started their married life only after becoming adult

women, with another ceremony known as *vidai/gauna*. Because of these peculiar circumstances, *vidai or gauna* (departure of the wife with her husband to start the married life) used to take place many years after the wedding, which has now been reduced to a few hours (sometimes even under an hour) as both are now adults. There are many names for this ceremony in different parts of India, but the process is similar.

The couple goes on a honeymoon or starts living together as husband and wife only after this ceremony. Therefore, someone not aware of the circumstances under which people opted for "child marriages" in some parts of India and, the complete process of marriage, are likely to draw inaccurate conclusions. It never meant either early married life, sex, or bearing a child. Sex with a minor, irrespective of her consent or not is considered as rape and, as such, is a punishable crime under the law in India. The marriage before the respective legal age is not considered legal in India.

India – a different perspective

Nowadays, with the changing times, child marriages are giving way to late marriages. A few odd instances of child marriages, from interior/remote regions are reported as the mainstream culture of India. Social psychology takes a longer period to accept the change in the name of tradition, although the tradition itself is born out of some specific conditions and should be discarded under the changed circumstances. Therefore, an odd instance of "child marriage" from the interior and remote regions of India should not be considered as the mainstream culture of India.

Another aspect of marriages in India which adds to the confusion of child marriages is due to the idiosyncrasies of the Indian languages. A female before the wedding, irrespective of her age, is referred to as a "girl" and a male before the wedding, irrespective of his age, is referred to as a "boy". A female is referred to as a "woman" only after her marriage, and similarly, a male is referred to as a "man" only after his marriage. In some colloquial dialects in India, a

India – a different perspective

woman means a wife and a man means a husband. The use of the term boy or girl in the context of marriage of adults has no bearing on the education, position in the society or age of the user. It is due to the literal translation of a marriable adult male or female from Sunskrit based languages in English.

Colonial India

It may be stated at the outset that Vasco da Gama is credited with the discovery of India by a sea route when he arrived at Kappad in Calicut (now Kozhikode) in Kerala on May 20, 1498. The motivating forces were to bypass the long overland route as well as the hostile attitude of Arab merchants. Arab merchants felt threatened that their business will be adversely affected by the intrusion of the Portuguese traders in their area of business in the East. This prompted Vasco da Gama to search for an alternative sea route for their trading activities in the East. Thus, the discovery of India by a sea route was incidental to the trading interests. The arrival of the Portuguese in India not only provided them with enormous opportunities to trade for Portugal but also opened the floodgates for traders of other European countries to enter into lucrative spice trade. Many European countries joined the trade race and established their trading centers in India. They established their colonies, to enhance their business interests

India – a different perspective

and to protect their trading centers, for varying periods of time. Following European countries had their colonies in India:

- Portuguese India (1501–1961)
- Dutch India (1605–1825)
- French India (1759–1954)
- Danish India (1820–1869) and
- British India (1613–1947).

The colonial era in India began when Vasco da Gama obtained trading rights from Zamorin, the local ruler of Calicut. However, Arab merchants were opposing the idea of establishing a European trading center. But the first European trading center was established at Kollam, Kerala in 1502. The Portuguese, thus, became the first to establish a colonial empire in the world. It may also be mentioned that the Portuguese were the first to arrive in India in 1498 and last to leave India in 1961.

The Dutch landed on the Indian coast next. They established The Dutch East India

India – a different perspective

Company in 1602 and trading centers along the Indian coast. They held control over Malabar, southwest coast, Cochin, Cannanore, Kundapura, Carmandel, southeastern coast and Surat during 1616–1795. The Dutch were able to take over Pondicherry from the French for sometimes and fortified it in 1693.

The French registered their presence in India when The French East India Company was founded in 1642. The first French factory came up in Surat in 1668. Chandannagore (now Chandannagar) was established in 1673 when Nawab Shaista Khan, the Mughal governor of Bengal, granted permission to the French. The foundation of Pondicherry was laid when Valikondapuram was acquired from the Sultan of Bijapur in 1674. However, the factories at Surat, Machilipatnam, and Bantam were lost to the British by 1720. The French had only commercial interests between 1720 and 1741. But after 1742 they started giving precedence to political interests over commercial interests. Hence all the factories were fortified. However,

the enclaves of Pondicherry, Yanam, Mahe, and Karikal were de facto transferred to the Indian Union on November 01, 1954.

The Danish were not far behind. The Danish East India Company was active from the 17th to 19th century. They founded Danish colonies with Fort Dansborg at Tranquebar as its capital, which was established in 1620 on the Coromandel Coast. The colonies included the town of Tranquebar in present-day Tamil Nadu, Serampur in present-day West Bengal and the Nicobar Islands, currently part of India's Union Territory of Andaman and Nicobar Islands. The company also established several commercial outposts which were governed from Tranquebar. In 1777 these became Danish Crown Colony.

With the passage of time, the British devastated the Danish East India Company's India trade and the Danish colonies went into decline. The British ultimately took possession of them

making them part of British India. It was all over for the Danish establishment by 1869.

The British also came to India as traders during the reign of Jahangir (1605–1627). But, far from being an honest trader, all of them had been indulging in what is known as "old-fashioned piracy"[12]. The "culture of large scale piracy and looting of each other's ships was rampant in the sixteenth century" and "piracy was openly practiced by the British on both sides of the Indian peninsula." Indian exports were adversely affected as "a direct result of Indian cargo being attacked and looted in the open oceans." Sometimes, the Indian traders "were forced to sell their products at a fraction to pirates masquerading as merchants." It was a "…..'golden period' of plunder." Strangely enough, the "English policy…..of pillage and plunder was common knowledge even in England." This resulted, on the one hand, in the utter ruin of, among other products, the flourishing textile industry in India and, on the

12 Tatya Tope's Operation Red Lotus by Parag Tope, Rupa & Co., 2010

other hand, a steep decline in cotton production which "was the backbone of Indian economy." Another disastrous effect on the Indian economy was that, since the British were also in "trafficking opium" trade by ships to China etc. "the cotton farms were replaced by the forced cultivation of opium." Hundreds of thousand acres "of land in northern and Central India was under opium production" turning India into the warehouse of opium. They became, in course of time, the main controller of trades in India to the exclusion of other European trading powers by getting a boost in 1661, when Mumbai (then Bombay) was given to Britain as part of Portuguese Princess Catherine of Braganza's dowry to Charles II of England. They controlled major parts of India from 1858 and were forced to leave India on August 15, 1947. Thus, bringing an end to the British colonial era in India.

Corruption

Corruption is bad and is led by influential people in power, who wield official, physical or monetary powers. Influential people are everywhere in the world. Corruption does not start, due to poverty or lack of resources. Rather, it starts with the money, due to greed and the lust thereof. There are so many faces of corruption, and there is no global definition of corruption. Corruption comes from illegal activities. What is considered corruption or illegal in one country is legal in another country. How can one compare corruption among different countries, without a common definition of the legal framework for all the countries? Is taking someone for lunch or dinner or giving gifts to a business associate legal or illegal? Based on your perspective and definition of the legal framework, one would answer and define it, if the payment of a simple thing like a lunch or a gift to a business associate is an act of corruption or not. This is an oversimplification of a complex global phenomenon. However,

everyone would agree that the legal framework is significantly different across countries in the world. One simple example is capital punishment. Based on the country one lives in; capital punishment can be termed anything between a barbarian act to an act of justice. This is true for many other aspects of life, including corruption.

Since this subject is so complex and there are so many ifs and buts, it is virtually impossible to nail down a global definition of corruption. Yet, somehow, people have concluded that corruption in India is among the highest in the world.

Now, let us examine the genesis of corruption— why (or how) does corruption start? And who is at the root of initiation of corruption? There are always at least two parties involved in any transaction. The CEO of a multinational organization offers a payout to a minister in a developing country for approving his/her business proposal. Who would you think is

corrupt—the minister or the CEO, or both, or none? Based on your definition of corruption, it could be any of the above four. As per my definition, there is a root cause of everything—who started it. In this case, the CEOs and their representatives are solely at fault for initiating something illegal for "their benefit." In the first place, if the CEOs from a developed country are determined to do business without any payout and do not offer a payout to seek a favor over their competition, we would not be talking about it. I completely disagree with the approach of putting the blame squarely on a minister from a developing country and giving a clean chit to the western organizations and their CEOs.

If all the CEOs from the Western world stopped offering a payout to the ministers in developing countries, do you think the ministers would not choose one of the options? Secondly, why would a CEO be offering a payout to anyone? Are the acts of CEOs ethical, and are they working within the legal framework of their respective countries? I never supported

India – a different perspective

anything illegal. The point I am making must never be construed as my support to acceptance of payouts by the ministers in developing countries. What I am trying to emphasize is that influential people from the so-called developed countries are more responsible for encouraging and nurturing the unethical behavior of the people in developing countries.

The Union Carbide Corporation plant, under the Chairmanship of Mr. Warren M. Anderson, was not maintained well, which resulted in the biggest industrial disaster in the city of Bhopal (Capital of Madhya Pradesh, India) in 1984. This disaster caused thousands of deaths from the poisonous gas leak and untold sufferings to hundreds of thousands. The people who suffered are still asking for justice, but the big corporate organization did not do much and tried to twist the justice system with their money power and influence. The Bofors arms deal, which involved payouts to ministers in India by the company, is still being discussed as an

unsolved mystery. The role of Swiss bank is worth mentioning here, in protecting the names of those who got the money in India through this deal, while Swiss bank took no time in ceasing the account of Julian Assange, the founder of WikiLeaks. Enron, which was involved in putting up a power plant in the state of Maharashtra, was caught in the scandal of payout to ministers and, later on, went bankrupt globally due to wrongdoing across the world in many other countries. Arthur Andersen was one of the "big five" financial consulting firms in the world, which audited the accounts of Enron.

This is not limited to developing countries like India. The payout by Siemens to Greek government officials during the 2004 Summer Olympic Games is another example of big corporation's money power. One of the ex-Prime Ministers of Canada had been charged with accepting a payout from an Airbus deal. Global financial meltdown, which started from the USA, had nothing to do with India or any other developing countries. People in these

India – a different perspective

multinational financial organizations were engaged in some illegal activities, which in my view, is no different from so-called corruption in India. There are many more names, and the list is endless. Who are running these multinational corporations? Where are their corporate offices? Who should one blame for corruption in corporations in developed countries? Are developing countries responsible for corruption in developed countries? And who should one make accountable for corruption in developing countries, in general, and particularly in India, due to these powerful multinational corporations? Do these multinational corporations from Western countries have any role in promoting and nurturing corruption in India? Why cannot big corporations from the developed world accept and tolerate a contract being awarded to their competitor?

I lived in India and, contrary to the popular belief, never paid a penny for getting any of my work done, whether it was for personal or for official purposes, and everything used to happen

through legal systems. There are legal ways to get the things done. But some people want to get the things done out of turn and are willing to grease the palm. The irony is that the same people speak of corruption in India.

There is one more aspect to it in daily life. India does not have a network of authorized agents. Like many Western countries, where the network of agents is authorized by the government agencies, there is a network of agents in India too, but it is not authorized by the government agencies. When one gets the work done by these informal agents, most of the people term it "corruption." The job being done by both the agents (one that is authorized by the legal system and another by someone, where there is no such legal system) is the same. This ties in with my earlier comment about the definition of corruption and the legal framework. In some countries, prostitution is legal, and in other countries, it is illegal, but the physical activity and financial transactions involved are the same. There is no system for authorizing

agents for most of the services in India, though things are changing now. The greatest achievement in neutralizing the corrupt practices in the Indian railways, which is the largest public transportation system in the world, goes to the ministry of railways in the government. The continued effort and commendable contributions by the ministry of railways has turned this enterprise into a profitable organization. However, a lot more needs to be done.

Crime on Women

Women in India are well respected like in any other civilized world and, therefore, I have a hard time believing that crime on women is more prevalent in India than it is elsewhere in the civilized world. The wife is called *ardhangini* ("ardhangini" is a Sanskrit word which means "better half"; "ardha" means half, and "ang" means body) and *grahlakshmi* ("grahlakshmi" is a Sanskrit word which can be translated as "someone who brings prosperity to home"; "graha" means home, and "lakshmi" means "the goddess of wealth"). Can a person commit a crime against someone they respect? Does anyone have any example where the followers have caused damage to the person they worship or the places they worship? Again, this argument should not be twisted, as if there is no crime against women in India. Mentally ill people exist everywhere. But in my memory, I have not seen or heard of crimes on women in India, as much as the media portrays it. Does it mean media in India is more vocal about crime on

women or the statistics of crime on women is inaccurate? First of all, one must remember that women in India are highly respected, and the public does not tolerate any misbehavior. Therefore, even a small incident is blown out of proportion and people in the West consider it routine. Remember, the population magnification factor about India, too.

Let me share few things about crimes on women in India and contrast this with other societies. If a person sees any wrongdoing against a woman in a public place or woman at a public place tells any stranger (whom she might have never seen before) that someone on the bus, train, or road is misbehaving and teasing her, the person or the public will neither call police as the first response, nor shy away from confronting the individuals. The public has three options either to confront the culprit and stop any further agony to the lady or to follow the law, inform the police, wait for police to come and let the law take the legal course or be oblivious to the surroundings. The people in India opt for the first option and

will stop that culprit from doing any further damage, sometimes using physical power, if the person fails to stop misbehaving, or teasing the woman. Police is called, and the person misbehaving is handed over to the police in the end. This is not a lack of respect for law and order but owning the responsibility of being a good citizen and protecting the women in the society. Compare this with the actions of neighbors when the house next door is burning. People do call the fire department, but they do not wait for the arrival of firefighters/fire tenders and watch people, and property burn. They try to save people and property in the meantime, as good citizens, which is not disrespect for the law.

Unlike many cultures, Indians never had the concept of a harem. They had a totally opposite outlook and tradition on dishonoring women or acquiring them as slaves. They neither indulged in the slave trade nor tried to dishonor or subject women to indignity. Let me cite an example or two to stress the point. It is said that when some

India – a different perspective

soldiers brought some women from the enemy side before Maharaja (King) Chhatrapati Shivaji (Shivaji Shahaji Raje Bhosle; 1642–1680), he not only reprimanded them, but ordered that all the women be sent back immediately with honor and under the protection of an escort, without any harm done to any of them. He was a royal blood; so now contrast this with someone on the other extreme—a *dacoit*, who is a criminal. Even these criminals (dacoits) in India maintained this tradition of honoring and sparing women when they raided a village, even if the women were laden with gold and silver ornaments. In a recent case (August 2010) of the kidnapping of a man for ransom, when his wife went alone into the desolate and dreary ravines to meet the kidnappers with ransom money and all her ornaments, the leader of the kidnappers neither touched the woman nor the money, nor the ornaments. Instead, the kidnapper offered her a seat and water to drink, presented her with some token money and trinkets from his side to show her respect, and immediately released her husband. Not only this, the leader asked one of

India – a different perspective

his men to escort both the woman and her husband to a safe place, and next day enquired from her if both had reached home safely[13].

In a society that respects women and takes care of them without any relationship and irrespective of their caste or religion, can the percentage of crimes against women in that society be high?

[13] The times of India date August 11, 2010

India – a different perspective

Dates, Calendar, and Time

Indian calendar and festival dates are based on a combination of solar and lunar movement. Unlike popular belief, it is not purely dependent on lunar movement. That is why Indian festivals do change the dates, but it changes in a range and does not move by a month every year (as it happens in the Islamic calendar, which is purely based on a lunar calendar). There is a fundamental difference between a lunar calendar and Hindu calendar. The Hindu calendar is based on calculations, unlike the sighting of the new moon as in the Islamic calendar.

There is a festival called *Makar Sankranti* (also referred to as *Sankranti*), which is always celebrated on January 14 indicating the transition of the sun from the sign Sagittarius (*Dhanu*) to the sign Capricorn *(Makar)*. It also marks a shift in the sun's path from northerly (*Uttarayan*) to southerly (*Dakshiayan*) direction. While the other festivals are based on a

combination of solar and lunar positions, Sankranti is based on solar movement. There are twelve months in a year and the New Year falls between March and April, depending upon the position of the new moon. The first of the month starts with the new moon and ends with the moonless night. The middle of the month is the full-moon night. Therefore, each month has two phases, and dates are from 1 to 15 in each phase. These dates are called *Tithi*. The last day of the month or the 15th day of the second phase is called *Amavasya* (moonless night), and the 15th day of the first phase of the month, i.e., middle of the month, is called *Poornima* or *Poornamasi* (full-moon night). However, this should lead to a reduction of about ten to twelve days every year, and festivals should continue to slide across the year, but that does not happen in the Hindu calendar. It is very complex to explain the addition of missed days as a month, according to the movement of the sun and moon. In simple words, the lost days in a period of three years are added back as an extra month every fourth year making it back to the

original dates. The names of twelve months and their corresponding zodiac signs are:

Name of the month	Zodiac sign
1. *Chaitra/Chait*	Pisces
2. *Vaishakh*	Aries
3. *Jyaishtha*	Taurus
4. *Ashadha*	Gemini
5. *Shravana/Savan*	Cancer
6. *Bhadrapad/Bhando*	Leo
7. *Ashwin/Knwaar*	Virgo
8. *Kartik*	Libra
9. *Margsheersh/Agrahayan*	Scorpio
10. *Paush*	Sagittarius
11. *Magh*	Capricorn
12. *Phalgun*	Aquarius

The names of the months are based on the zodiacs (*Rashi*), where the sun transits within a lunar month. There are twelve zodiac (Rashi) names and, hence, there are twelve months.

There are seven days in a week, and each day has a relationship with a planet. *Var*

India – a different perspective

(pronounced as vaar like bar) in Hindi means day. Names of Hindi days, their corresponding English day, and the represented planet for the day are given in the following table.

Hindi day	English day	Day and planet
Ravi var	Sunday	Ravi = Sun
Som var	Monday	Som = Moon
Mangal var	Tuesday	Mangal = Mars
Budh var	Wednesday	Budh = Mercury
Guru var or Brahaspati var	Thursday	*Guru*/Brahaspati = Jupiter
Shukra var	Friday	Shukra = Venus
Shani var	Saturday	Shani = Saturn

Indians have developed a system of calculating a very small fraction of an hour and very precisely. Each day consists of twenty-four hours, divided into eight equal parts called *pahar* or *prahar*. Therefore, each prahar is three hours long.

Prahar is divided into six *muhurta,* i.e., each *muhurta* is approximately thirty minutes long. It is further divided into *laghu, kastha, kshan, nimesh, lava, vedha,* and finally *truti.*

Each truti is about 0.0004 seconds. This is a very small fraction of time used in calculations in the Indian astrological system. I hope it provides some insight into the preciseness of this ancient science in India, which is still used for many purposes.

Dot

A dot on a forehead, as perceived by the Western communities, is not merely a cultural practice or a part of the make-up. It has deep medical reasons, besides it acts as a means of beautification too. The reasons for most of the things prevalent in Indian culture are not conveyed properly and there is a general perception that people in India do it just because it has been done for generations. However, everything has a reason, which may not be known to most of the people, including people living in India. It is like asking someone the reason for driving on the right-hand side of the road in North America, instead of driving on the left-hand side of the road. After a while, these things become a social practice but most of the people do not know the answer to the question "Why is it so?" The colored substance put on the forehead is called a *tika/tilak/bindi* which is commonly referred to as a dot on the forehead in the Western world. When one applies it to one's forehead it acts like acupressure and,

India – a different perspective

while putting it on, one must fix one's gaze in the middle of the forehead and between the eyebrows, which results in as an exercise for the eyes and brain (concentration) for aiming right in the middle of the forehead. This helps calm down both the persons, who has put it on and the person, who is looking at it. The substance used has medicinal values for the person applying it during the day e.g., sandalwood paste provides cooling effects.

Similarly, nose and ear piercings are acupuncture of the nerves. The piercing, using pins, hoops, rings, etc., are used as ornaments, made of silver or gold. Silver and gold have medicinal value on the human body and these items are made of high purity, generally 20 to 24-carat gold in India.

Bangles are worn by girls and ladies, which are made of gold, silver, copper, and glass. At least a few are made of gold or silver. Whenever the hand is moved, these bangles act as a source of mild and constant acupressure on the wrist.

India – a different perspective

Similarly, necklaces, bracelets, anklets, and toe rings are worn for medicinal reasons, as each acts as a source of natural acupressure.

Nowadays, people in the West have gone ahead with piercing and tattooing all over the body, and it has become a fashion of the West.

India – a different perspective

Eating with the Hand

Eating with the hand may be culturally shocking for someone who is used to eating with fork and knife. But people from Indian sub-continent to Middle East countries generally eat with their hands. People eating with fork and knife also use the hands for holding it when eating. The same hands are used for washing, wiping, drying, and placing food on the table. People in India wash their both hands before eating the food as well as after finishing the food. One of the reasons for eating with the hands, besides being the most hygienic, is that the texture of the Indian food is not suitable for eating with a fork and knife. Someone might argue that we eat everything in Indian restaurants with fork and knife, but that is flawed thinking on three counts. First is the habit to use fork and knife. The second reason for this perception is that the cuisines one finds in Indian restaurants and that, too, in Western countries are very limited, as compared to what is eaten at homes in India. And lastly, anything can be eaten, as one

pleases; e.g., wine can be relished in a soup bowl with a spoon, but that, I guess, the wine drinking community will consider it gross.

Taking the food with a fork and knife involves the use of only four out of the five senses for experiencing the food; i.e., listening, seeing, smelling, and tasting. When one touches the food with the right hand (which is used for eating in Indian culture), one is using all the five senses (listening, seeing, smelling, tasting, and touching).

I am also told that there is a relation between cosmic energy and the fingers when one eats by hand. It is said that cosmic energy from the body passes on to the food through the tips of the fingers of the right hand and the food becomes charged with the cosmic energy. Both the hands are never used while eating food.

Only the right hand is used for making a morsel and putting the food in the mouth. When the fingers touch the surface of the plate or bowl, it

puts pressure on the fingertips and acts like natural acupressure and helps in the digestion of the food. Indian food is eaten steaming warm and touching it with fingers also helps in sensing the temperature of the food before putting it in the mouth and burning the tongue.

Therefore, eating with the hand may be unusual for someone who is not accustomed to it, but it certainly is not unhygienic.

Eco-Friendliness

Indians are traditionally and culturally an eco-friendly community and have been so for thousands of years. Let's examine various things in life from birth to death to see how the balance has been maintained with the environment for so long. The recent influence of industrialization, which is limited to under 20 percent of India's population, has created many problems, just as it has in any other industrialized nation, but in India, it is a minuscule compared to the Western industrialized world. People in India used to preserve food grains in large earthen pots. The food was cooked in earthen pots. The milk was boiled in earthen pots and yogurt was prepared in earthen pots. Similarly, butter and pickles were stored in earthen pitchers. The cooking stove and oven were made of clay. Drinking water was stored in ewers made of clay called *Ghara* or *Surahi*. People in most of the homes (including metro cities) use these for keeping drinking water even now. These clay pots act as

natural coolers. The food was and still is served in plantain/banana leaves in many homes, during community feasts, and in social gatherings. The leaves are properly washed with water before the food is served on these. Wherever plantain/banana leaves are not available in sufficient quantity, the plates (called *pattal*) and bowls (called *dona*) are used. *Pattal and dona* are made of leaves (*patta)* of Dhak (*Butea frondosais*) which are sewn with thin twigs (each like the size of half a toothpick). The small bowls (called *sakora*) and the glasses for drinking water (called *kullahad*), used in social feasts, are made of clay. These things were meant for one-time-use and were then dumped, along with the crumbs, in a pit for making organic fertilizer, which was used in the agricultural fields. The earthenware and leaf-made articles are still in use in many areas in spite of the availability of plastic/china article. Cosmetics were prepared from organic ingredients. Leaves of *mehndi* or *henna* (*Lawsonia Inermis*—from the family of *Lythraceae*) is ground and applied for

decorations on the body (tattoos) and for dying hair, instead of using chemical dyes. Paintings made with herbal colors about 4000 years ago are still available in many places in India. Obedullaganj, Vidisha, and Panchmadi are three such places in Madhya Pradesh near its capital city of Bhopal, where I have seen these paintings. The details of discoveries of these places were written with synthetic paints, which started fading/peeling within a couple of years, implying that synthetic material does not necessarily outlive organic material.

Chemical fertilizers and pesticides were not in use in India until the middle of the twentieth century. Manure and organic fertilizers were used in farming, and organic pesticides and herbicides were used in farms in India. Ashes of empty maize cobs, when sprinkled on the field acted as a deterrent to the crop-damaging insects. Similarly, *neem (Azadirachta Indica)* was used in many diseases and in homes as disinfectants and antiseptics. Dry leaves of *neem* were kept with woolen clothes, instead of

naphthalene balls, and this is still a practice in many homes in urban India. Chemical toothpaste and toothbrushes were not used. People used to chew the tender twigs of neem or *babool* (*Acacia Nilotica*) to make a toothbrush and clean their teeth. There was no need of paste with this natural toothbrush. It was meant for one-time-use and, hence, the concept of "use and throw away" existed for thousands of years in India. Neem's medicinal values are now known to the world. When one uses a neem twig as a toothbrush, it provides protection against bacteria in the mouth.

It is also now known that the use of soap and chemicals for cleaning a surface or washing hands has limited value in killing bacteria. It is the scrubbing action that cleans the surface or one's hands from bacteria. The majority of people in rural India, even today, use ash or clay for cleaning their hands and cleaning kitchen metal wares. People used to take baths with various organic substances including clay, gram flour, turmeric powder, milk, and yogurt. A large

number of people, even today, use Indian gooseberry (*amla*) and Acacia Concinna (*shikakai*) powder or its liquid extract for shampooing their hair. It not only cleans the hair but also provides many vitamins and minerals to hair. Amla is a very rich source of Vitamin-C (many times stronger than an orange) and iron. The washed-out water does not contain any synthetic chemical requiring any type of effluent treatment.

However, metro cities are highly influenced by developed countries and use excessive chemicals, without realizing the long-term consequences. But, still, there is no concept of drying clothes in dryers even in metro areas. All families in India, both in urban and rural areas, dry their clothes in the sun in all weather. Sunlight is the natural source of heat for drying and disinfecting the clothes and does not require burning coal or gas for generating electricity, required for running the dryers. Many people in urban areas have started using washing machines, but they too dry the washed

clothes in sunlight after spin-drying. Most of the clothes washing machines in India have tumbling action only, i.e., not even spin drying. People squeeze the clothes and hang them on a wire or rope in the sunlight for drying. This is practiced throughout the year and not just limited to summer months.

The concept of conserving electricity by using fans instead of air conditioners or using room air conditioners instead of central air conditioners, using fluorescent tube lights or energy-saving bulbs, instead of incandescent bulb has been in practice for a long time. Generally speaking, people are very conscious about the environment and try to reuse things as long as they can. The concept of keeping waste/disused papers, plastic, glass, aluminum, copper, and steel items separately in the house/yard/barn and selling it to a vendor is very common. Almost no one throws any of these items in the garbage. Vendors visit the homes regularly for picking up these items and selling them to industries for reprocessing. The awareness

about recycling the items and protecting the environment has existed in India, both in rural and urban areas, as long as I remember, since my childhood.

India – a different perspective

Education System

The world's oldest educational institution, Takshashila University was in the western part of Punjab, which was a part of India before 1947. Now it is in Pakistan. Takshashila University was a center of advanced learning, dating back to at least the fifth century BCE. Another institute of repute, Nalanda University was in present-day Bihar in India. People from across the world used to come for learning to these universities.

Fa Xian (337–Circa 422 AD), a monk from China visited India, between 399 AD and 412 AD. He came to India to learn about *Buddhism* and also visited *Lumbini* in Nepal (the birthplace of the Buddha) and Sri Lanka.

Huan-Tsang (Circa 602 AD–664 AD) from China traveled to India through treacherous mountainous routes and stayed for many years in India learning its rich cultural heritage. He spent many years at the then world-famous

India – a different perspective

institution of education, Nalanda University in Bihar, learning Sanskrit and Buddhism.

Al Beruni (Circa 973 AD–1048 AD) a Persian scholar/philosopher and Ibn Battuta (Circa 1304 AD–1368 AD), a Moroccan scholar are among the well-known scholars/philosophers who visited India for learning philosophy, religion, and Sanskrit.

Both universities were destroyed by invaders. The manuscripts were written on tree bark/leaves and, hence, most of them were burnt. India also had a wonderful and holistic education system where disciples used to live with a *guru* for a long period of time to learn from him. The place was known as *gurukul* (*Guru*'s place). Children used to begin their education on the auspicious day of *Basant Panchami* in spring (*Basant* means the season of spring), after performing the rituals for Goddess Sarasvati, the goddess of learning.

India – a different perspective

The foreign rulers enforced their own state-controlled education system to cater to their needs and interests which, on the one hand, not only destroyed the independent *Gurukul* system of education imparting liberal and broad-based education, but, on the other hand, also pushed the flourishing and most scientific Sanskrit language on the brink of extinction. It is said that Sanskrit is the most scientific language and the best suited for computer programming.

Now, India has an education system, which is very similar to the education system in North America. There are some differences, too, but they are minor in nature. Before diving deeper into this section, there are some similarities and differences worth mentioning here.

- Secondary boards in India include elementary, primary, and secondary education and are responsible for the entire education program before the university level.

India – a different perspective

- Primary education is up to grade five (also referred to as "class-5"), and institutions imparting primary education are called primary schools.
- Many schools are from nursery to grade twelve and are sometimes also called colleges.
- Many schools are from grade six to grade twelve and are called intermediate colleges. Schools up to grade ten are called high school.
- Grade nine and grade ten, together, is called high school, unlike North America where the high school is grades nine through twelve.
- High school is not grade twelve in India. Grade eleven and grade twelve, together, are called intermediate or plus-two (high school plus two, or ten plus two).
- Grade ten and Grade twelve have board examinations and separate certificates are issued for high school (Grade ten) and intermediate (Grade twelve).
- Students after Grade ten can take many diploma courses, but all the university

courses are after grade twelve. These courses are offered by universities or affiliated colleges (sometimes referred to as degree colleges).

- Undergraduate studies in North America are referred as Bachelor or Graduate studies in India, which can take anywhere from three years five years of full-time study. Universities or their affiliated colleges offer these courses.
- Graduate degrees in North America are called Post-Graduate or Masters in India and generally take two years of full-time study. Universities or their affiliated colleges offer these courses.
- Minimum qualification for entry into the undergraduate (Bachelor) engineering program, which is for four to five years, is grade twelve with physics, chemistry, and math. The degree offered after completion of these courses is a Bachelor of Engineering or a Bachelor of Technology or a Bachelor of Science in Engineering/Technology. The graduate degrees offered in Engineering in

India are called Master of Engineering/Technology and the terminal qualification is a Ph.D.

- Minimum qualifications for entry into the undergraduate (Bachelor) medical program, which is for five to six years, is also grade twelve with physics, chemistry, and biology (zoology and botany). This is different from North America, where a Bachelor of Science is the minimum qualification for entry into a medical program. Math is not required in grades eleven and twelve for medicine. The most common degree offered after completion of a medical program is MBBS (Bachelor of Medicine and Bachelor of Surgery). Individuals having MBBS degrees are recognized as qualified doctors and can practice family medicine and select surgeries. Further specialization is called MD (Doctor of Medicine) or MS (Master of Surgery) in the respective fields and the terminal qualification is called DM (Doctorate in Medicine), like DM in Cardiology,

Neurology, Nephrology, Gastroenterology, etc.
- Further studies are similar to that of North America and take place at universities.
- Universities are governed by the University Grant Commission (UGC), which works under the guidance of the Ministry of Education.

Every school in India is affiliated with one of the education boards. The school boards in India are slightly different from school boards in North America. Some private schools are affiliated with the International Baccalaureate (IB) program with headquarters in Geneva, Switzerland.

There are two national boards, the Indian School Certificate Examination (ICSE) and the Central Board of Secondary Education (CBSE), which are designed, keeping in mind the needs of children of federal (central) government employees, who are transferred routinely across Indian states and Union Territories. In the year

1958, the Indian School Certificate Examination (ICSE) was created to replace the Cambridge School Certificate Examination, UK, by an All India Examination. In the year 1958, the Central Board of Secondary Education (CBSE) was a reconstitution of U. P. Board of High School and Intermediate, with a few other education boards. The U. P. Board of High School and Intermediate was the first education board in India, set up in 1921. In the year 1962, the jurisdiction of CBSE was further expanded beyond the national geographic boundaries. As a result of the reconstitution, the erstwhile "Delhi Board of Secondary Education" was merged with the Central Board of Secondary Education and, thus, all the educational institutions recognized by the Delhi Board became a part of the Central Board. Subsequently, all the schools located in the Union Territory of Chandigarh, Andaman and Nicobar Islands, Arunachal Pradesh, the state of Sikkim, and now Jharkhand, Uttaranchal, and Chhattisgarh have also got affiliation with this Board. The board had a small number of 309 schools in 1962. The

number of school in the board has grown to 19,316 schools in India and 211 schools in 25 foreign countries as on July 26, 2017. The composition of 19.314 schools includes 1,118 Kendriya Vidyalaya (Central Schools), 2,734 Government/Aided Schools, 14,860 independent schools, 590 Jawahar Novodaya Vidyalayas and 14 Central Tibetan Schools[14].

Besides these two central boards, there are state boards for many states for fulfilling the needs of children who do not intend to move across the states during their education years. These state boards serve the entire state. There is no concept of district school board as in North America. Figure 1 provides a high-level overview of the structure of primary and secondary education systems in India.

14 http://cbse.nic.in/newsite/aboutCbse.html

India – a different perspective

```
                    ┌──────────────┐
                    │  Education   │
                    │   in India   │
                    └──────┬───────┘
             ┌─────────────┴─────────────┐
             ▼                           ▼
     ┌──────────────┐            ┌──────────────┐
     │  Government  │            │   Private    │
     │   Schools    │            │   Schools    │
     └──────┬───────┘            └──────┬───────┘
        ┌───┴───┐              ┌────────┼────────┐
        ▼       ▼              ▼        ▼        ▼
     ┌─────┐ ┌───────┐      ┌─────┐ ┌───────┐ ┌──────────────┐
     │State│ │Central│      │State│ │Central│ │International │
     │Board│ │ Board │      │Board│ │ Board │ │ Baccalaureate│
     └─────┘ └───────┘      └─────┘ └───────┘ └──────────────┘
```

Figure 1: Structure of Primary and Secondary Education in India

There are two parallel education providers, as in North America: (i) government and (ii) private organizations. Government schools have two flavors:

i. The schools run by the state board and following the curricula of a state education board.
ii. The schools run by the central government and following the curricula of CBSE. Some of these schools are called Central School (*Kendriya Vidyalaya*; *Kendriya* means central and *Vidyalaya* means school).

But Private schools have three flavors:

i. The schools following the curricula of a state education board,
ii. The schools following the curricula of one of the two central boards,
iii. The schools following the curricula of the International Baccalaureate (IB).

Some of the private schools have day-boarding or day-night boarding. Schooling in most of the government schools is free to both male and female children. Some school boards provide meals to students in government schools, too. Government incentivizes those studying in the government schools and provides the meritorious students with scholarships.

The concept of homeschool is virtually non-existent for both government and private schools. One can choose any school and admit his/her child into any school. However, admission in good schools is based on competition, and this competition starts from the admission into kindergarten. The process is relatively simple in government schools, but

many schools run by government are also very high in demand, due to their quality of education, and admission is very difficult in those schools. As a result of this process, parents prepare the children well in advance for attending the schools and behaving well in class. More and more schools are turning to co-education, but there are gender-based schools, too.

The choice of subjects generally starts from grade eleven, but in some state boards, it starts from grade nine. The Indian education system provides wider exposure to students from an early age. There is a lot of focus on the quality of handwriting, the correctness of spelling (of course, the UK English), understanding and usage of proper rules of grammar, the formation of sentences, and mental math (addition, subtraction, multiplication, and division). Parents and teachers work together in the development of children. Parents prepare their children for behaving well in the school. Children are encouraged to understand that a school is a

place for learning; they have to respect the educator, and any time wasted will never return in their lives. As a result, there is hardly any time wasted by teachers in classroom management. The concept of split class is not a normal mode of teaching in metro areas, the capitals, or big cities. The accent of two primary languages Hindi and English vary among Northern, Southern, Eastern and Western states within India. India being a multicultural society, one can find teachers from many states/religions in a school. But, students, their parents, and colleagues do not discriminate between teachers based on their accent, religion or region.

Generally, from grade three onwards, there are subject teachers; i.e., math teachers teach only math to various classes, science teachers teach only science in many classes, and similarly, language teachers teach only languages to many classes. The concept of a math teacher learning social science for grades six, seven, and eight a few nights before, and teaching to

students in India is unheard of. Games and sports are an integral part of every board's curricula. A physical trainer runs the physical training (PT) classes and, similarly, sports teachers teach sports.

The concept of subject teachers provides far superior education to students and comfort to parents and teachers. A social study teacher does not teach science, math, English or music to the students. Music teachers do not teach other subjects, nor do teachers of other subjects teach music. Who gets the most benefit? Students, who are the future of the nation. They do like studies because they have the teachers who can fulfill their inquisitiveness. What about teachers? They enjoy teaching the subject of their choice and are not stressed out learning different subjects the night before and teaching the same the very next day.

Teachers in India are responsible for students' success and answerable to parents and school authorities. Parent-teacher meetings take place

every month, where a student's progress is shared.

There are religion-based schools (Catholic, Islamic etc.), too, but one is not required to follow their religion for studying or working in those schools. There are separate schools for children who have any kind of challenges in learning and require special accommodations. This provides consistent education to the rest of the students, and a majority of the students in the class do not suffer, due to one or a few of the challenged students, and it is far better for challenged students who get 100 percent attention from the qualified teachers. This also reduces pressure on educators, as they do not need to prepare multiple lesson plans for each class i.e. one lesson plan suffices for the entire class. The absence of split class also eliminates the need for preparation of multiple lesson plans, and 100 percent of the time is given to the students of the same class.

India – a different perspective

Final examinations of Grade-10 and Grade-12 are conducted by the respective boards on the same day across India (or State) at the same time. The question papers are set by a panel of teachers of the respective subjects from the boards' curricula. Therefore, every student is evaluated on the same questions and it removes any biases of the teacher of a class or a school. Here, I would like to clarify that each questions paper contains multiple questions, sometimes in multiple sections, and students are required to answer only a few questions from the entire paper or from each section to take care of differentiated instructions. The answer books are checked by subject teachers from different schools in different cities and sometimes in different states. It further eliminates any biases in evaluation by the same teacher who taught the subject or by another teacher in the same school. It also encourages teachers to complete the entire course as well as students to prepare for the entire course. In case the entire syllabus is not completed due to any reason, the teachers organize extra classes

to complete the course and students attend these classes because neither the subject teachers nor the students know the questions of the final exam until the question paper is distributed. The panel of subject teachers prepares three sets of similar (but not identical) question papers and the board officials randomly choose one of the papers for distribution. The process is similar for undergraduate and graduate studies. However, there are a few exceptions to this process in professional studies (engineering, medical etc.) only at undergraduate and graduate level in the autonomous institution.

Transcripts and certificates are issued only once and to the student. The concept of issuing transcripts (or certificates) multiple times and that too to other institution is not known in India and the process to do so seamlessly over the internet or sitting in different city or country exists by the exception in any university or secondary board.

India – a different perspective

The important thing is that we realize that the Indian education system, with all its shortcomings, is, if not superior, a comparable system in imparting quality education and building rock-solid foundations from a very young age. It prepares the children for facing the challenges in the future. It nurtures them for success in higher education and in future careers. People in North America are realizing this. The President of the USA, Mr. Barak Obama, tried to revitalize the education system of the USA so that children in highly- advanced education systems of the USA can compete with students groomed through the so-called inferior quality of education from India.

I am not suggesting that there is no scope for improvement in the Indian education system. Anything and everything has a scope for improvement everywhere. Here, my emphasis is on distinguishing between the two systems, halfway across the world.

India – a different perspective

The single most important difference between the two systems is that the North American education system applies the filter of quality from later years in high school onwards, and the Indian education system applies that filter of quality from admission in nursery school onwards. As a result, there are more non-high school people in India, but there are fewer dropouts in high school in India because who had to drop out had been stopped long before coming up to grade nine. But the current Indian education system is not the most sought after by the elites in India either, due to the hype about the North American education system. The Indian educationists are trying to ape the North American education system without realizing the associated problems it has created in the Western world. The Indian education system is blamed for focusing on memorizing the stuff. I do not understand the logic behind this belief. The Indian system of education builds a strong ability to do mental math, unlike the popular belief that it consists of memorizing. The students are given ample opportunities for

India – a different perspective

extensive practice of every subject which is conveyed as memorizing. Students learn the subjects by practicing it over and over.

I would like to mention a few examples from North America about mental math, which is popularly misunderstood as memorizing. I presented $20.19 for the items costing $19.19 and asked the counter person to return $1.00. The counter person looked at me, first as if I were an alien for asking $1.00 in return and then, after punching in the amount I handed him into the electronic ledger, the same person looked at me in disbelief for calculating it mentally. Are you wondering why I did that? To reduce the number of coins in my wallet. I taught at a college in Toronto, Canada, and in one of the economics classes I was teaching, a student perplexed me by asking the process of dividing two integers (double digit)! She was very proud to say that she had studied it twenty years ago in high school and, hence, I should not expect her to remember the process of dividing two integers. Once a hospital staff gave me an

India – a different perspective

appointment for a specialist couple of months later for November 31, and I immediately said there is no 31st in the month of November. Neither did she realized her mistake nor believed me, and she turned many pages of the calendar to verify the number of days in November; upon verifying that November does not have thirty-one days, she complimented me as a "genius" for instantly pointing it out.

Children in India are not allowed to use a calculator until they go for professional studies, unlike North America where calculators are provided from early primary classes. The concept of using a calculator for any purpose, including scientific calculations, up to grade twelve is an alien concept in India even today. Emphasis is laid on performing these calculations mentally or using pen and paper.

I find many people in the Western world, including elite Indians, mentioning the term "illiterate" for people in India who do not have a formal university education or cannot speak

India – a different perspective

English, or who do not wear Western clothes. Whereas these so-called "illiterate" people can read, write, and perform complex calculations without using a calculator in their regional languages. Just because they do not have a formal education at the university level or they cannot speak English, calling them illiterate is a very myopic view of literacy. They are taught at home by their parents, elders, neighbors or in nearby schools. An example is the large community of vendors, who buy and sell, take care of their accounts and, more importantly, make profits from their business. One would be amazed to see the speed and accuracy of calculations they perform when you buy many items at different prices and in fractional quantities. But these people are generally referred to as "illiterate" by elite Indians because of a lack of formal education at the university level. I witnessed the most glaring example of this attitude when an MBA student in Canada, born and brought up in India referred to the famous "Dubba-valas" (lunch couriers) of Mumbai as "illiterate"!

Overall, the Indian education system is a strong education system. It produces excellent scientists, engineers, doctors, professors, IT professionals, you name it. The in-depth knowledge of the field in which a person has studied is unparalleled. Yet the irony is that Indians and Westerners together believe that the education system of India is inferior to that of the Western education system. The West does not tire of complaining about the Indian education system, and Indians do not tire of echoing their views about the Indian education system. Both forget that all the professionals coming to the Western countries are successful because of their education in India. Anyone who has done high school from India virtually glides through a university without any trouble in the USA and Canada. Still, the Indian education system is considered inferior to the Western education system both by Indians and Westerners alike. I do not feel Westerners are completely responsible for this belief. The onus is on Indians who have the knowledge about

India – a different perspective

both the education systems. However, I wonder why people in North America do not try to reason it out with the number of professionals from India arriving in North America and succeeding.

Look at the number of scientists, doctors, engineers, professors, etc. in the USA from India and try to solve the puzzle as to how can so many Indians work in the USA as doctors, engineers, scientists at NASA, professors in universities, and professionals in the corporate world, despite their so-called poor education from India.

Female Children - Privileges

There is a belief in India that a family is incomplete without a girl child. The birth of a girl child is not only considered auspicious but signals the arrival of Lakshmi, the goddess of wealth, in the family. A home without a female child in India is often referred to as a haunted house. And still, the position of female children in India is depicted as underprivileged—how strange!

Without a proper understanding of the social and cultural values, any discussion about the privileges of female children has insignificant meaning. This has a lot to do with the history of foreign rule in India and the family background. This was not the case in ancient times. The problem of the safety of children and women raised its ugly head with Muslim raids and rule.

India – a different perspective

However, during the Mogul, and subsequently, during the British period, female children and ladies were not safe. They were abducted by the ruler community. As a result of this, the majority of people in India developed a habit of protecting female children in the family and the community by means of restricting their movement alone and late at night. This has been communicated in recent times as curtailment of the privileges for female children in India. This perception or conclusion at the present time does not have an iota of truth.

There is another factor worth mentioning. India got independence about sixty-five years ago. During the partition, many families had seen the brutality on their families, especially on women, and female children. That generation, though growing old, is still alive. They have passed on this knowledge based on their personal experience to their offspring for the purpose of protection of their grandchildren. And some of the families are still trying to protect their female children in the same manner, although times

have changed. If someone wants to call protecting a child as withdrawing privileges, then one is right.

Girls before the age of puberty are not only worshiped with all sincerity and devotion, twice every year during *Navrati* festivals, held in March/April (depending upon the position of the moon) and in September/October (depending upon the position of the moon) but also venerated as living goddesses in some areas. People bow before them and show reverence by touching their feet. The result of this ritual is that the elders treat all the girls in the vicinity as daughters. These girls are given gifts, clothes, money, and a feast. This is celebrated across the vast country in different forms, but the common underlying belief is to protect, care for, and praise the females. On the other hand, the male siblings of these female children get nothing on these two occasions. Actually, there is no such celebration for boys in India. There is another festival in India, known as *Rakshabandhan*, celebrated in the month of

India – a different perspective

August/September (depending upon the position of the moon) in which the sisters tie a silk thread (called rakhi) on their brothers' right wrist. The brother, in turn, offers clothes, sweets, and money with a promise to protect her. Another festival showering love and care to the girl child is *Bhai-Dooj*, which is observed twice a year, strengthening the bond of love between brothers and sisters. It is like Sister's Day on which a brother showers his love and affection on his sister(s) in many ways. It is observed on the third day of *Holi* (which comes in March or April) and *Deepavali* (another name for *Divali*, which is the festival of lights; it comes in October/November). The reason for celebrating these festivals in India is to teach the male population from a very early age to respect and protect females in the society. The families who have only one child or all the children of the same sex (male or female) request their relatives or neighbors to send their children to celebrate these festivals.

India – a different perspective

I am talking about the majority of the areas where girls are as free as a boy. They do everything a boy does. But remember that India is a huge country with over one billion people. Therefore, assuming it does not happen in even a single family may not be the right conclusion. People do all sorts of wrong things with their children, including fathering grandchildren from their own daughters in the developed world. The word "incest" is derived from the Latin word *"incestus"*, establishes the antiquity of this perversity. However, it can neither be generalized nor can everyone in the developed world be viewed with this doubt.

Look at the games in which woman athletes from India have been participating, since independence, and you will find that female athletes from India have been participating in every sport and game. Further girls are studying in every field and excelling in it. There are utter miscommunications and distortions of the facts about protecting the female children in India as underprivileged.

Food

Most of the people in the West believe that Indians eat a lot of fat in their food all the time. This perception is due to the fact that some of the people love Butter Chicken and, as the name suggests, it has lots of butter. It is also due to the kind of food that is available in Indian restaurants. Let me ask a simple question. How many people eat at home, the kind of food one gets in a restaurant, irrespective of the origin or country of the food? Or how many people drink at home, the kind of drinks one gets in a bar? Another important fact about die-hard fans of butter chicken is that in terms of the percentage of India's population of 1.2 billion, butter-chicken enthusiasts, both at home and at restaurants in India, would not even form one percent of the population. Did it make you think...hmmm?

No Indian eats the kind of food one gets in an Indian restaurant on a routine basis at home. It appears to have a lot of fat, which is true in restaurants only, but not correct for the kind of

India – a different perspective

food eaten at home. One has to look at the total intake of all the nutrients in twenty-four hours too. There is no concept of taking juice or pop (aerated drinks like Coke, Pepsi, and Ginger-ale, etc.) or wine or any alcohol with the food in the Indian system. These things are very high in calories. Indians drink plenty of water without any additives during the day. However, only a little amount of water is taken with meals, because it is recommended, for medical reasons, that one should not take a lot of water along with food for proper digestion of the food. Traditionally, India has more vegetarians than non-vegetarians. Vegetarians are not vegans. Although vegetarians in India do not eat eggs and fish, they do take dairy products and honey. There are people in India who are vegans, too. A majority of the non-vegetarians do not eat pork or beef. They eat meat (goat), mutton (lamb), fish, and chicken. Traditionally speaking, a majority of the non-vegetarians were rice eaters, and vegetarians were either wheat, sorghum(*Jwar*), Pearl millet (*Pennisetum glaucum or Bajra*), corn or rice eaters. Wheat

and rice dishes were not eaten together, be it vegetarian or non-vegetarian. Even today, this tradition continues in most of the homes and in social gatherings in rural areas and small towns in India. The only exception is social parties (e.g., birthdays, weddings, official gatherings, etc.), homes in metro cities, where cross-community marriages are increasingly taking place, and in restaurants. There is a wave of cross-migration between vegetarians and non-vegetarians. Vegetarians are switching to eating non-vegetarian dishes in the name of modernization, and non-vegetarians are now changing over to vegetarian food for health reasons.

Within the boundaries of the vegetarian and/or non-vegetarian divide, there is another layer of complexity called regional cuisines and regional flavors, which are broadly North Indian, South Indian, East Indian, and West Indian foods. If one superimposes the regional variation over vegetarian and/or non-vegetarian food, it becomes overly complex to explain the variety

India – a different perspective

of foods in India in a few pages. An example of the variation in cooking is the medium of cooking oil, which may be mustard oil, peanut (groundnut) oil, sesame (gingili) oil, or coconut oil. The oil used in different parts of India is distinctly different, and that provides a distinct flavor to the food. Remember that the oil used in the past and still in most of the places (villages are about 75+ percent) is natural oil produced from oilseeds and copra and untreated with any chemical (unrefined). Another example is the spices used in cooking, which are very regional. Most of the people confuse spices with chilies, and peppers. Spices provide flavor to the food and chilies, and peppers make the food taste hot. Other spices do not taste hot but provide aroma to the food.

India has been known for centuries for producing many spices. Arab and European traders were drawn towards India since the 16th century for the spice trade. One of the reasons for an increase in health issues among Indians in metro cities is that people have started eating

everything without realizing that digestion cycle for various types of protein is different; besides, the modern lifestyle does not provide enough opportunities for physical work. The food in India was created, based on the climate, working habits, and facilities then available. Today, things have changed, but people still continue to take the same type of food, especially in metros, without realizing that they no longer need it. This is another reason that these health problems are concentrated only in metro areas in India, while the countryside is yet to be infected with the Coke, Pepsi, pizza, burger culture.

Now, look at the ingredients of Indian food, its preparation, and consumption patterns. First of all, everything is cooked or boiled, which kills most of the bacteria. There is a very limited concept of eating salad in Indian food. It is a modern addition. Secondly, Indian food is eaten within a few hours of its preparation, while it is still warm and fresh. Eating reheated food is an exception, rather than a rule, and is not approved or appreciated by the elders. Indian

food is very healthy, due to various spices put into it. These spices have great medicinal values, such as turmeric, which is put in almost all curries and has antiseptic and anti-inflammatory properties. Cumin seeds are rich in calcium; *asafetida* is good for digestion and reduces gas formation. There are other examples, but this should suffice to show how and why spices are used.

Another important thing about the actual food served in homes in Indian communities, versus the food served in Indian restaurants, is that one eats *nan* (most likely Butter *nan*) made of an all-purpose flour, which does not have any roughage. At home, none uses all-purpose flour. People use whole-wheat flour for making *chapatti/roti* (bread), which is much healthier than nan or butter-nan, though certainly does not taste as good. It is the same as choosing white bread over brown bread. One tastes good, but the other is good for health, though it does not taste as good. Can you make this choice at restaurants in the US and Canada? Of course,

yes, but you are likely to get bread made of the same all-purpose flour in these two countries. But if one asks for whole-wheat roti (bread) in restaurants in India, one shall get it made from whole-wheat flour. It is a question of economy of scale at the restaurants; besides, people go to restaurants to get pampered. Who wants to eat the same homemade stuff at a restaurant, or why bother going to a restaurant to eat the same home-style food?

Similarly, Indian rice eaters do not eat *pulav* or *biryani* at home every day, which is prepared with fried rice, as opposed to the boiled rice. Rice eaters eat plain boiled rice with curry (fish or mutton or vegetable) or lentil (*dal*) or yogurt (plain or *kadi*). Plain boiled rice does not have any fat whatsoever. *Pulav* or *Biryani* is meant for special occasions. Unlike dining in restaurants where one consumes Pulav or Biryani with many other wheat dishes, Pulav or Biryani is almost never eaten with other wheat or rice preparations at home.

India – a different perspective

A great emphasis is laid on the freshness of the food items in India. Almost all of the families in India (excluding a few families in metro cities) use fresh vegetables, and fruits and, therefore, they eat seasonal fruits and vegetables. Someone may argue that Indians are deprived of the privileges of consuming any fruit or vegetable at any time of the year. But I cannot explain the taste of fresh fruits or vegetables to someone who has never tasted them. There is no match in the taste of a fruit or vegetable, which is fresh from the orchard to those that are a couple of weeks old after being transported or even frozen vegetables or fruit. Similarly, a large majority of the population in India does not use canned food items.

Well, do you really care about health over savoring great food once in a while in Indian restaurants? Hell no! Then enjoy the great-tasting Indian food as much as you can. It is unequivocally the greatest tasting food in the world. But do not draw the wrong conclusion that Indians eat it every day at home.

Greetings

When meeting a person, the normal gesture is saying *Namaste* or *Namaskar*. Folding hands, bowing a bit and saying *Namaste* or *Namaskar*, is a sign of respect if the person is older in age or has higher stature due to learning, and wisdom. If the person is a spiritual leader or an elderly family member (both male and female), most of the Hindus bow and touch their feet as a sign of regard. However, in some communities, unmarried girls do not touch the feet of anyone. Elders shower their blessings in return by placing both their hands or just the right hand on the head of the younger person or by hugging them. Who touches whose feet is also dependent upon the relationship, which is slightly complex to explain. The traditions of greeting have some regional variations too.

Hugging and kissing are confined between family members, and I feel that keeps people of India healthy. It is now common knowledge and there is enough material easily available on the

web, which tells the problems caused by just touching a person who is suffering from a viral infection without knowing yet that he or she has an infection.

However, there is a festival called *Holi*, which is the festival of color. It is celebrated in March/April (Spring). People apply dry-colored powder (called *gulal*), spray colored water, and serve sweets, snacks, and cool drinks. The colors used to be prepared from organic material like petals of dried flowers, but synthetic colors took over in the past few decades and now, again, people are emphasizing the use of organic colors as synthetic colors affect skin and eyes. During this festival, people hug each other, after applying the color, irrespective of the relationship. This is celebrated by all the people in the society and not limited to a community or family members or friends. There is a saying that people celebrate *Holi* with enemies too and forgive them after hugging.

India – a different perspective

The world had stopped shaking hands, hugging, and kissing on meeting during the SARS and the recent H_1N_1 flu pandemic. Indians practiced it all the time. Shaking hands with strangers by no means is hygienic; besides, one does not know the medical conditions of the people, which can harm the persons shaking hands. Now, medical science has confirmed that, during the gestation period, the carrier of a virus may not have any symptoms but shaking hands will still transfer the infection to many people before anyone knows it. Many deadly viral diseases can be transmitted from contact with the saliva or sweat of an infected person. Therefore, I guess that this method of greeting was designed after careful considerations of the health of people at large and might have helped Indians during outbursts of many infectious diseases. However, in a business environment, people have been shaking hands for decades. But hugging and kissing in a business environment or with non-family members has not started yet.

India – a different perspective

Grown-up Children Stay with Parents

As described earlier, India is a pluralistic society, where society, family, and family ties are considered extremely important. "Adults stay with their parents" is only half the truth. Parents and grandparents also stay with their children when they grow old. The children consider it fortunate to serve their parents and grandparents. There were no old-age homes in India. However, this concept has started making in-roads in metro cities recently. Parents take care of adult children and these adult children, in turn, take care of parents and grandparents later in life. This tradition is so strong that even unmarried or widower uncles and widow aunts also stay with their nephews and nieces.

This is a perfect example of a win-win situation. This also shows cooperation among family members of different generations. Grandchildren grow up under the supervision of

their grandparents, while the parents are focused on building their careers. Children are never neglected this way. Children get the cultural and family values from their grandparents and children see that their parents are taking care of their grandparents or great uncles and great aunts.

This makes the older people in the family feel wanted and useful which keeps them occupied with children and happy. Older people learn many new technological inventions from young children at the same time, when they are imparting values and the importance of being good human beings to their grandchildren. Older people have all the time in the world to explain the tiniest inquisitiveness of the young minds, whereas parents neither have the time nor the patience for quenching the thirst of inquisitiveness of innocent minds.

Children are much safer with their grandparents and are taken far better care of by their grandparents than any daycare center. The cost

India – a different perspective

of daycare centers is another burden to parents, besides worrying about their children all the time. I guess, if not all, most of the parents would agree, that they would trust their parents over any daycare center, when it comes to handling their children. The role of a seasoned- elderly and known person becomes more important if your child has special needs. Who would you trust more than your own parents? Or can you trust anyone more than your own parents?

Can the person at a daycare center pay special attention to the needs of an individual child? How realistic is this expectation? Do you believe that the best daycare professional would be able to match the love and affection of average grandparents, besides imparting the values?

Let me share a story, narrated to me a long time ago. The story took place somewhere in the UK in the early twentieth century. A young person was walking with his father to drop him off at an old age home. Halfway on their journey, they sat down on a culvert. After a while, the old man

started sobbing. The young man thought that his father had become emotional or feeling insecure for the fear of being abandoned and ignored by his family now. So, he went over to his old man and tried to console him. "We are all together; we are not abandoning you; we will visit you every weekend…" The old man regained his composure after a while and said, "Son, I am not weeping for fear of being abandoned or feeling insecure or anything to do with you or your family." The young man was puzzled and asked, "Then why are you crying? The old man replied, "This is the place where I sat down about fifty years ago when I was going to drop off my father."

I do not know the truth about this story, which was once told to me by an elderly person, Mr. P.N. Bahadur, from my community when I was about fourteen or fifteen years young. Perhaps I did not appreciate the moral of the story then. But I carried the simple message, and now I have a much better appreciation for this story.

India – a different perspective

So, it is true that children stay with their parents after becoming adults, but they take care of the people who took care of them as a child when they become much older and need nearness to family members rather than a nurse. It is a concept of give and take. A child's needs were taken care of by the parents; now a grown- up man takes care his parents in old age, who, in turn, take care of grandchildren, just as his children will take care of him when he grows old, and thus, life moves on.

This is true for education and marriages too. The entire expenses for education of boys and girls are borne by the parents. They do not need to worry about earning their own tuition fees, books, food or pocket money. Once the children grow up, they go to colleges/universities for higher education and later get married. The entire expenses for the education and the marriage are borne by the parents. In some regions, the marriage expenses are borne by the maternal uncle or maternal grandparents. Parents do not have to save a lot for their post-

India – a different perspective

retirement life. Once the education and marriages of the children are over, their financial obligations become minimal, because their children take care of most of their daily needs like home, food, clothes, medicines, etc.

If you contrast this system with the Western system, it is not hugely different. It is a cycle. The culture in India focuses on "We." The cycle starts with "We" and ends at "We." Total financial obligations or financial requirements during the entire life of a person remain the same. Only the "obligation to" and its time changes. Whether you take care of your education or your son's education, the time value of the money is the same. Whether you take care of your marriage or your son or daughter's marriage, the time value of the money still remains the same. Whether you pay for childcare or you keep your parents with you, who take care of your children, besides providing great values, the financial obligation is going to be the same.

India – a different perspective

This structure is already broken in metro cities, but it takes time to break a cultural tradition, which has been continuing for the last many thousands of years for millions of generations. Is it good for the society or will it be good for society in future? I do not know and cannot predict.

Idol Worshiping

The Indian system of prayers, since olden times, is one of the many forms of worship. It is one of the ways of being in communion with God as there are different stages of evolution and salvation. The Indian philosophy of life also believes in the cycle of birth and death, rebirth, and incarnations.

Different ways of worshiping have been defined as forms of devotions in the *Bhagavat Purana*. The different attitudes (*bhav*) reflect the differences in the temperaments and the approaches in the devotees. However, the intense and selfless love for God is the common factor in all of them. The nine forms of devotion as described in the holy books are:

1. **Listening:** Listening devotional songs, recitations, lectures, and scriptures arouse feelings of devotion and love in the heart of the listeners.
2. **Chanting (*kirtana*):** Praising the existence, and the presence of God by singing hymns,

songs like carol or popular hymns to the accompaniment of *harmonium* (keyboard instrument similar to a reed organ. Sound is produced by air being blown through sets of free reeds, resulting in a sound similar to that of an accordion) and *Tabla* (percussion) or simply *Ektara* (single string instrument used by saints.) This is a way of joyfully keeping concentrated on the Divine through music.

3. **Remembrance (*smarana*):** This means to think constantly of God by either recalling His glories or by constantly repeating His name using a rosary.

4. **Service:** Worshipping the feet can be a part of the ceremonial worship of God.

5. **Ritualistic worship (*archana*):** This is through the performance of prescribed devotional rites.

6. **Prostration (*vandana*):** This would be described as a gesture of surrender towards God.

7. **Servant attitude (*dasya bhav*):** In this form, the devotee performs every act as a service to God.

8. **Friendship (*sakha bhav*):** This describes a very intimate and close state of association with God like a friend, as a result of long, sincere and devotional practices.
9. **Self-offering:** This is the stage of complete surrender, where the devotee worships and loves God without any thought of reward or personal gain.

The ultimate aim of devotion or worship, irrespective of form, is the merging of the individual soul with the Universal Soul thereby liberating the devotee or the worshiper from the endless cycles of birth and death. It is believed that with this union the devotee is liberated from the cycle of birth and death, which is the ultimate goal of every individual soul whether one knows it or likes it or not. It is like a raindrop falling in the ocean and losing its identity.

Why do people worship an idol when most of the people understand that it is only a man-made image of God and not a God? An idol is a symbol of God. None has seen God, and none can define it. So, it becomes difficult for a person

India – a different perspective

to concentrate on something not visible. It is more like explaining the flow of electrons or the flow of current to high school students. They struggle to visualize these theories, even though they can see the effects of current in a bulb through a switch. For a child or someone not so interested in theories, or preoccupied with wordily duties, explaining the concept of God is much more difficult. And in the absence of anything visible, a person is very likely to lose faith in God.

Therefore, common persons worship idols as a means to focus or concentrate on God. It also keeps them engaged during different stages of life. People pray, sing, dance, and meditate in the front of these idols and build a connection with God through the idol.

Does everyone worship idols in India? The answer is definitely no. People choose other forms of meditation depending on the level of understanding of God. Some use other means, like the Rosary (*Tulsi mala* or *Rudraksh mala*)

made of "Holy Basil" (*Tulsi*; Botanical name *Ocimum tenuiflorum* or *Ocimum sanctum*) or *Rudraksh* (Botanical name – *Elaeocarpus ganitrus*) for meditation. Sometimes, these beads are made of sandalwood or gold or coral or some other gemstone, metal, or plant. Here, I wish to mention something I wondered since I first learned about the "periodic table of elements" in 1977, and that is why there are only and exactly one hundred and eight beads in a rosary in ancient Indian system of worshiping. I have read many explanations, and I will mention only a few, which make the most sense to me and, therefore, the list is not exhaustive. This also does not mean that other explanations are not valid:

1. There are one hundred and eight atoms in Nature according to ancient Indian science, which is now also more or less confirmed by the modern periodic table of the elements.
2. The number of Upanishads (ancient Hindu holy scriptures) is one hundred and eight.

3. The number of psychiatric illnesses, according to Ayurved (ancient Indian medical system), is one hundred and eight.
4. The number of sensate foci in a human body is one hundred and eight.

There is another category of people, who by sitting in a meditation posture and closing their eyes are able to focus on God. They do not need the support of a rosary or an idol to connect with the invisible and shapeless God (*Nirankar*). Balmiki, Buddha and many others did not use any idol or any other form of support for their meditation and evolution.

Medical System

India has two parallel modern medical systems—one is provided by the government, and the other is provided by private hospitals and individual practices. Figure 2 provides the snapshot of prevailing medical systems in India.

Figure 2: Structure of Medical Facilities in India

The Indian government medical system has two types—insured and uninsured. The Government-insured medical system is known as Employees' State Insurance Scheme (ESI) is for all employees in the private sector (shops, hotels, restaurants, cinemas, road motor transport undertakings and newspaper

establishments etc.)[15], up to a certain annual income level. The Government non-insured medical system is open to all, including those who are covered in ESI, as well. In government, non-insured hospitals, one has to pay very nominal fees for a doctor's consultation, medicines, tests, and surgeries.

I am sure many readers must have chuckled reading the words "nominal fee." Therefore, it is prudent to provide a few examples of the fee to put the things into perspective. One example is the All India Institute of Medical Sciences in New Delhi. This is the biggest hospital in India and ranks number one in terms of the quality of medical services it provides and the number of patients it handles. I think this hospital must be number one in the world for handling the highest number of patients every day, every year. This hospital also ranks number one for providing medical education, and there is a very tough competition for entry into becoming a medical

15 http://www.esic.in

student at this premier institution, perhaps the most difficult in the world. The fee for registering at this hospital is about US $0.20 (it is not an error—it is 20 cents), and this fee allows you to see any doctor, including a number of specialists (neurologists, cardiologists, ophthalmologists...) for up to ten visits in a calendar year. The cost of chest X-rays is about US $0.75. Other government hospitals are generally more economical. And remember, anyone from the poorest of the poor to the richest of the rich can go there and get the same services for this royal sum of money. One can see virtually any specialist the very same day. However, if one prefers a particular doctor, there might be a wait time of only a few days, and this is because every doctor does not visit the Out-Patient Department (OPD) every day. The OPD is where doctors see non-hospitalized patients and is similar to the urgent care, or walk-in clinics in North America (but also for specialists). Doctors are involved in medical research and teaching, besides taking care of

those admitted to the hospital for more serious ailments.

The Government medical system (both insured and non-insured) is very similar to the medical system in Canada. There are nominal charges for non-insured patients. However, in India, it does not have the limitation of going to a specialist through a family doctor. Anyone can see any and as many doctors as one wants, directly, without any referral by the family doctor. One can seek a second, third...opinion in a matter of a few hours or days, if not satisfied with the first.

One can walk into the office of any specialist, including an ophthalmologist, gynecologist, neurologist pulmonologist, or orthopedist and get a consultation the same day in government hospitals in New Delhi. This is true for all the metro cities, capitals, and the big cities in India. This is considered and publicized by the misinformed and ignorant media as an inefficient and poor medical system of India.

India – a different perspective

None waits for ultrasound and x-rays for more than a few hours. MRI and CT Scans are normally scheduled within a few days (generally within a week) in these so-called, inefficient government hospitals in India. There are many such hospitals in New Delhi. Some other well-known government medical institutes are Safdarjung Hospital, Ram Manohar Lohia Hospital, Maulana Azad Medical College, Lady Harding Medical College, and the list is not exhaustive. Besides these big and specialized hospitals, there are smaller hospitals in every city and dispensaries in towns/villages across India.

Now let us have a look at the private-sector medical system. There are many private hospitals and private doctors in every city and town. I cannot say this for every village (countryside). But there are villages where private doctors also practice, though it is not lucrative for the doctors.

India – a different perspective

The world's third largest hospital is Apollo[16] with branches in many cities within and outside India. It has all the state-of-the-art equipment and teams of specialist doctors under one roof. One can consult any generalist to a specialist the same day for $10~$20 per consultation. The typical wait time for seeing a doctor or a specialist is under thirty minutes. Doctors at this hospital are also engaged in research, teaching, and taking care of some of the most complicated cases admitted to the hospital from around the world. The cost of a typical cardiac bypass surgery is approximately US$5000, but one gets this service the same day if required, or it can be scheduled within a week, based on the mutual convenience of the patient and the availability of the doctor. MRI and CT scans and ultrasounds are done within a few hours on the same day a patient takes the requisition to the radiology department. Forget about waiting for x-rays. X-rays are done within a few minutes, unless it requires any preparation on patients'

16 http://apollohealthresources.com

part, such as having an empty stomach. I never heard of anyone taking appointments for x-rays or ultrasounds in India. This is at the highest end of private medical services in India. The cost is relatively high because it is a corporate organization. This is not the only private hospital in New Delhi but waiting for specialists for months or for x-rays and ultrasounds for weeks is an alien concept in India. In fact, if a person waits for more than thirty minutes in a private hospital or for a specialist appointment in the government hospital longer than a week, the system is highlighted as terrible. Some other private hospitals are Fortis-Heart Institute, Sir Ganga Ram Hospital, Batra Hospital, Medanta in Gurgaon, Fortis-Escorts Hospital and Sunflag Hospital in Faridabad, and the list is not exhaustive. Similarly, there are many multispecialty hospitals in Mumbai, Chennai, Kolkata, and other big cities in India.

At the lowest end of the private medical services, a doctor is available within a radius of a few mile/kilometer (1 mile=1.6 kilometers) and

India – a different perspective

costs as little as $1. Just because their consultation charges are so little, it does not mean that they are either incompetent or the quality of their services is poor. Many do this as a service to humankind at very nominal charges. I have known doctors who did not ask for any fee, and it was left to the patient to decide the fee for the services taken and put it in a dropbox. Besides, the cost of living in the local region is also to be considered.

The private-sector medical system takes care of both insured and non-insured patients. The medical insurance is very similar to that of the USA. But most of the people do not go for medical insurance, because medical services in India are affordable and doctors have excellent clinical knowledge. They do not depend entirely on tests. This keeps the cost significantly lower.

Now let us talk about the knowledge and skills of the doctors and medical staff. I have many examples where doctors have diagnosed the problem and prescribed the treatment without

any tests. On the insistence of the patients, doctors requested the tests but told the patients that it was for their satisfaction and what the expected result would be. And these diseases were varying in complexities from Hepatitis-A to tuberculosis (TB) to auto-immune- neuropathy to malaria.

Private hospitals have air-ambulances, too, but generally, in the case of an emergency, one gets the medical attention first from a doctor in the vicinity in no time. In the case of a medical emergency, one rushes to the emergency ward in a government hospital and cannot imagine waiting for hours to be seen and/or treated by a doctor. Generally, people do not go to an emergency ward, unless it is a real emergency, because people in India have alternate medical services available 24/7 in the vicinity. I do not feel shy admitting that, contrary to popular belief, the Indian medical system is far superior, compared to the way it has been communicated to the world. The ability to diagnose clinically

and the knowledge of the medicines among doctors in India is unmatchable.

Besides the modern medical systems described above, many alternative medical systems like Ayurved, naturopathy, homeopathy, and Unani etc. are also available in India. The institutions providing treatment through alternate medicines range from medical colleges with facilities for teaching to students the science of alternative medicines, and admitting/treating patients with serious illnesses, to individual practice. There are many research institutes for alternative medicines. These are recognized and regulated by government agencies.

Generally speaking, the cost of treatment through alternative medicines is relatively less than the cost of treatment through modern allopathic medicines. And these alternative medicines are not limited to metros or big cities.

Origin of Religions

Hinduism, if not the oldest, is one of the oldest religions and has diversified into many streams. Many religions have evolved from Hinduism. With the passage of time, people formed many sects for various reasons, and some of them are now considered separate religions. Let's talk about two main religions, which have evolved from Hinduism, namely Sikhism, and Buddhism.

Sikhs are very big-hearted, brave, hospitable, and welcoming people. There is a Sikh regiment in the Indian army, which established them as a martial race. There are innumerable stories of their bravery on battlefields. These people belong to the state of Punjab, the western part of which is now in Pakistan. The land of Punjab, being the land of five rivers, is very fertile, and these people are very hard working. They played a vital role in producing food grains and making India independent in meeting the internal food- grain demand.

India – a different perspective

The term *Sikh* was derived from Sanskrit word *Shishya* (which means disciple) and Sikh means learner (disciple of a *Guru*). They have been mistaken many times by the Western world for being Muslims, due to their beards and turbans. But they are distinctly different from them. Sikhs did not wear turbans and did not carry anything special, as a religious identity, until the end of the seventeenth century.

Sikhism was founded by *Guru* Nanak Dev (April 15, 1469–September 22, 1539), who was born in a Hindu family. He was born in a *Kshatriya* family in a village, now called Nankana Sahib, near Lahore, Pakistan (before 1947, it was part of India). He was married to Sulakhni and sired two sons, Shri Chand and Laxmi Chand.

Guru Nanak Dev was the first of the ten Sikh Gurus. However, he chose one of his disciples Bhai Lehna as his successor and renamed him as *Guru* Angad to be the next *guru* for leading the disciple community. This also confirms that

the caste system was based on the type of work one did and not based on birth.

It was the last and the tenth *Guru* of Sikhism, *Guru* Gobind Singh (December 22, 1666– October 07, 1708), born in Patna, Bihar (India), who created a military organization to fight against the atrocities of Muslim ruler Aurangzeb (1658 AD-1707 AD) in India. He gave them a visual identity to distinguish people of this organization from the rest of the people of the society, and a dress code was formed in 1699. They carried five things as a symbol of their belongingness to this organization. Each of these five things started with a letter "k" in Hindi. These things are namely "uncut (long) hair" (*Kesh*), boxers (*Kachchha*), sword (*Krapan*), comb (*Kunghi*), and an iron bracelet (*Kada*). These five things were their identity like today's military uniform for identification.

Besides, it was needed in those days to distinguish them from intruders. This community expanded by providing the eldest male child

from each Hindu family to this organization for protecting and serving the nation. They were provided with training in combat and military skills.

The tenth *Guru*, Gobind Singh, did not announce any successor and left it to the members of this organization to self-manage it through the preaching of Gurus. These preachings were recorded and are called *Guru Vani* (Voice of the *Guru*; "*vani*" means voice) and enshrined in the sacred *Guru Granth Saheb* (holy book of Sikh religion). The place where Sikhs go to pray, to recite, or to listen to the religious discourses of Gurus is called *Gurudwara* (the entrance to a *guru*'s place).

One of the important features of this religion is the concept of Community Kitchen known as *Langar*. It was ordained by their *Guru* that freshly cooked food must be ready all the time so that a hungry passerby or a traveler or one who rests at the place for the night, gets food and that nobody sleeps on an empty stomach.

This practice is religiously observed in all the *Gurudwaras*. The food is cooked and served with all the devotion.

Another important feature of this religion is the concept of Community Service (*Kar Seva*) which everyone feels privileged to do happily, and with all sincerity. Lastly, their traditional dance (*Bhangra*) is an icon of celebration.

Another religion known as Buddhism has its origins in India, too. It was founded by Gautam Buddha. Before he became enlightened after intense meditation for years, he was known as Prince Siddharth Gautam (Circa 563 BCE–483 BCE), who was born in Lumbini, which is now in Nepal. He was the son of the King of Kapilvastu, Suddhodhan, and Queen Mahamaya. He was brought up with all the privileges enjoyed by a prince. He married Yashodhara, and they had a son named Rahul. As the legend says, one sage visited King Suddhodhan soon after Siddharth's birth and predicted that his son would leave the palace in search of the truth of life after seeing

a death. King Suddhodhan was upset with this forecast and created an environment, which never allowed Siddharth to see any death, serious sickness, or any sufferings. One day, however, he chanced to see a dead body for the first time in his life, and sufferings of people. He realized that life was mortal. Realizing that his life was mortal, too, he turned himself away from the comforts of the palace, left the kingdom, his wife, and a son, and, at the age of twenty-nine years he immersed himself into meditation.

He meditated under a Bodhi (*Pipal*) tree in a small place called "Bodh Gaya" (in Bihar, India) for a long period of time, and got enlightenment after about six years of deep meditation there. After the enlightenment, he set out to preach the masses about the truths of life and he became known as Gautam Buddha.

Ashok (304 BC–232 BC) was an emperor of Maurya Dynasty, who conquered and ruled the entire Indian subcontinent stretching up to present-day Afghanistan in the west from 269

India – a different perspective

BC to 232 BC. The emblem of India is the design of his pillar, called Ashok Pillar (Ashok *Stambh*; *stambh* means pillar), which has four lions sitting back-to-back, facing/watching in all the four directions. After conquering the Indian subcontinent, he realized that wars caused lots of bloodshed, death, and destruction and, found people still suffering not only from the deaths of their dear ones but also from the ravages of the war. This led to a change in his heart; he became Gautam Buddha's disciple and started spreading the teachings of Gautam Buddha, the sheet anchor of which is non-violence, and peaceful coexistence. He sent his son Mahindra and daughter Sanghamitra to Ceylon (now Sri Lanka) to spread the teachings of Buddha. He also spread the teachings of Buddha across his kingdom from many Southeast Asian countries to the Middle East. He converted his entire military cavalry into a non-violent farming community, as a gesture to show his commitment to non-violence. As the name and fame of Buddha's teachings spread scholars from far east and from the west started coming

to India to drink the nectar of knowledge at Nalanda, and Takshashila and started learning about Buddhism. These followers of Buddha's teachings are now known as Buddhist or followers of Buddhism.

Parents and Children's Education

Do parents in North America not want their children to go for higher education? Do parents in North America not expect the wellbeing of their children? If so, are parents in India any different from the parents in North America? What is wrong if an Indian parent wants the same from their children?

The parents in India, like any other sensible parent in the world, expect the wellbeing of their children and constantly bring awareness to their children about the benefits of higher education, later in life. The parents in India finance education for their children and children do not have to worry about paying the debt for their education. Therefore, parents expect that their children study hard and graduate with flying colors. No parents—does not matter if they are in India or in any other part of the world—would like someone, including their son or daughter to

India – a different perspective

waste their money. If you are paying for the higher education of your son or daughter, would you not like your son or daughter to be successful? Is it unfair to ask them to succeed in their chosen field of studies? I am not defending the parents who want their sons and daughters to become doctors, whereas the son or daughter wants to be an actor or actress. And these kinds of parents are in every society in every country, with no exception, even in India.

Parents in India do not worry much about them and try to take care of the future by investing in their children's education even if it meant some personal sacrifices on the part of the parents. Every person takes care or tries to take care of the finances of the education of their children—not for themselves.

Who is more mature to think if higher education is going to be more beneficial in the long-run in life—a child or a middle-aged woman/man, who also happens to be the mother/father of the child? If a child starts earning as a teenager,

where do you think his or her priorities will be—studies or leisure? Children are under tremendous persuasion in India to complete their education, but they do not have to worry about anything else.

There are many people who are recognized as great people, without any formal education. Can this logic be applied across the board for stopping all the formal higher education?

I have heard from many children that their parents want them to go for higher education or to study in a university so that they can boast about them in among their relations and friends. I found the parents were speechless with this argument. They had no answer to this allegation. I asked those parents to go to their children and ask them—do these children like bragging about the toys they have or the car or home they have or where they have gone on vacations? Do they care about the place their parents work or the type of jobs they do? Would they like to earn good money through legitimate

means or work at a place that pays the prevailing minimum wages in the area? Why do children desire these things? So that these children can brag about their parents! Do children expect any different from their parents?

Both parents and children want that the other persons should do well in the society, but the burden is put on parents, that they should not expect it from their children. Is this a fair expectation from the children and anyone who supports this argument? In my opinion, Indian parents are no different than parents in any other part of the world. Parents' expectations from their children are universal.

Poor and Rich

There is a large segment of the population of the middle-income group in India, between the two extremely small segments of populations at the opposite ends of the economic scale. Compare this in the USA and Canada, and the degree of disparity is the same. On one hand, people have their own jet planes and, on the other extreme, people do not get a square meal in the USA or Canada either.

The problem in seeing this is the optics of comparison. I remember from one of my management classes, a professor compared the cost of intercity courier service by a local operator in Mumbai in US Dollars with the cost of FedEx in USD in New York. Is this comparison fair? What's wrong with this comparison? Both are providing the courier service in USD. Well, the problem is that he forgot to find the price of intercity courier charges by FedEx or its equivalent in Mumbai. Does it really make any difference, or how much

India – a different perspective

difference will it make? Any guess? The original comparison was about $0.10 v/s $25.00; whereas, if you consider the local cost, this difference shrinks to $0.10 v/s $0.50. In his comparison, the magnitude of difference was 250 times; whereas it was only five times. Five times the difference is no small difference, but it is negligible when compared to two hundred, fifty times.

This comparison skews reality in India manifold and readers are shocked, looking at the income of a so-called poor person in India; whereas that meager salary in India can bring a lot of stuff for that person's family. Let me illustrate this point with a simple example. The cost of a kid's meal at McDonald restaurant, which is considered expensive and a luxury food, as compared to local food in India, is about US$1.2, including taxes against the US$6+ in North America, or the cost of a cup of tea (coffee is not a usual drink in India and Asia in general) is about US$0.10 and a cup of Nescafe Coffee is about US$0.25. A cup of tea at the lower end of tea

India – a different perspective

stall can be as low as US$0.04. Another example is the full-size loaf of bread in the middle of price distribution is about US$0.40. Compare this price with the average price of bread of the same size in Canada i.e., US$2.40 which is six times the cost of the same item in India. However, this cheap price is considered expensive in India and there are further economical and more nutritious alternatives available in India.

Every family from the middle-income group in India can afford a maidservant, but a family from the similar income group in North America cannot. I can go on and on, comparing the prices of commodities and services in India with little meaning. The bottom line is that, despite the disparity in income groups, people at the lower end of the income group in India are able to bring sufficient food to the table with the money they earn, so comparison of just the income in dollars between rich and poor in India, alone, has little value for people in North America or Europe.

India – a different perspective

I would also like to remind the per capita annual budget of India is about one-fiftieth of per capita annual budget of the USA.

Religious Harmony

India is a vast country with population of about 1.2 billion professing and practicing different faiths. The Christian population is about 80 percent of the entire population of Canada and more than the Christians in Canada. The Muslim population is about 4.5 times of the entire population of Canada. In any family, where the number of members is more than one, there are always some differences of opinions, some rifts, and sometimes, some tension, too. Does it fundamentally break down the family structure?

The same is true for India. Besides, there are media personnel sniffing for the smallest possible sensational item to convert it into full-blown breaking communal news. I am not denying that there is no conflict between communities, but it is the same as what happens in any society. Just because India has a multicultural society, journalists always bring forward the religion of the parties involved in any

India – a different perspective

conflict, thus converting a simple issue between the two parties as communal.

Despite, much advertised religious/communal tension across India, there have been three presidents from the Muslim community: Dr. Zakir Husain (1897–1969), the third President of India, from May 13, 1967 to May 03, 1969; Dr. Fakhruddin Ali Ahmed (1905-1977) the fifth President of India from August 24, 1974 to February 11, 1977; and Dr. A.P.J. Abdul Kalam (Born-1931), the eleventh President of India, from July 25, 2002 to July 25, 2007[17]. This is a country with supposedly a Hindu majority. The very third president of independent India was a Muslim in 1967; the seventh president was a Sikh. I happened to have done my high school from Hafiz Muhammad Siddique Islamia Inter College, Etawah, which happens to be the school for the first Muslim president of India. This school is not for Muslims only, nor does it teach any religion. I have been taught by many Hindu, Muslim, and Christian teachers.

17 http://presidentofindia.nic.in

India – a different perspective

Students from different religions study in these schools, and teachers with different religious backgrounds teach in the very same school. My wife Neeta had studied and later taught in a Christian School (Carmel Convent Public School) run by a missionary. Being Christian was not a prerequisite for being a student or a teacher in that school. There were many nuns, though, but that is normal in a missionary school in India.

So, why do we hear so much about religious tension in India? Because of such news, though small (most of the time irrelevant), is converted into a front-page story. A majority of the cases related to religious tension in India are examples of making a mountain out of a molehill. Religion is one's faith. It is to be followed if one believes in it. Does any religion teach creating disharmony, trouble for others, tension in the neighborhood, or causing harm to innocent people? People in India follow various religions, and everyone is free to do so in the world's biggest secular democratic country.

India – a different perspective

Does it create tension among the population? No. But it does reduce the importance of a few. Therefore, to maintain their hold on the population, and keep themselves in limelight, these people create mischief. The media blows it up out of proportion, and the innocent public suffers. There have been cases where the public did not get carried away by such news initially until people were prodded, and the media published it as religious disturbance among the communities. Unfortunately, international media also play a very marginal role, and they do not verify the truth before publishing or broadcasting it.

I was doing my masters in Bhopal and staying in a hostel at the time of the demolition of Babri Mosque at Ayodhya (Uttar Pradesh). Nothing happened in the peaceful capital city of Bhopal for the first forty-eight hours after the news of demolition. Life was normal—no riots. Then some of the influential people started coming to the city. And soon, the peace disappeared, and the media were all along watching, and

publishing the distorted news adding further fuel to the fire. There were Muslim students among us staying in the hostel. None ever felt or talked about harming anyone. We all ate, drank, played, studied, and stayed peacefully and together, even during this period of an artificially "created" religious crisis.

In general, there is no communal tension in India. No one cares about other's religion and, honestly speaking, no one has time to look into these things. It is a very peaceful country where people from all religions participate in the festivals of other religions. Muslims prepare fireworks for *Dushahra*/Divali and the Hindus share the joys of Id and Christmas. Hindus visit mausoleums (*dargahs*) of Khvaja Gharib Navaz in Ajmer (state Rajasthan), of Nizamuddin Auliya in New Delhi, and of Haji Ali in Mumbai (state Maharashtra). Besides these, people from different religions visit Mount Merry Church located in Bandra (West), Mumbai (Maharashtra).

India – a different perspective

India is a secular country where Muslims are free to announce the time of prayers on loudspeakers five times a day. It is a country where Zoroastrians, Jews, Baha'is practice their religions and celebrate their festivals freely and without any hindrance from rest of the communities.

I have stayed in a house, whose owner was a Christian in a Hindu majority state. Its location was of strategic importance from the point of view of religious harmony in the Indian society.

The three religious places of worship—a church, a temple, and a *gurudwara*—were a stone's throw away from this house. At the back of that house, there used to be mass gatherings of Christians every Sunday. They used to pray, sing religious songs, and pastors delivered sermons. This used to happen every Sunday from 9:00 a.m. to 1:30 p.m. It, of course, created noise pollution, but none in the neighborhood felt that it should be banned or countered with any action. Similarly, about 50 meters from the

same house, there was a *gurudwara* and a temple. They too celebrated their religious functions and added to the noise pollution, but no one ever felt like doing anything against any of the religions.

Another way to look at this aspect is to review the list of actors, actresses, music directors, singers, and many others in the Indian movie industry. This list is too long to write all the names and writing a few names may not do the justice to the missing names because every one of them has a place in the industry and people love them. People of India love these people from film industry because of their work and not because of their religion. This trend did not start in the twenty-first century. Actors Suraiya, Nimmi, Nargis, Naseem Bano, Meena Kumari (Mahjabeen Bano), Madhubala (Mumtaz Jahan Begum Dehalvi), Mumtaz, Zeenat Aman, Dalip Kumar (Yusuf Khan) and Sohrab Modi, singers Mohammad Rafi, Talat Mahmood and Shamshad Begum, music directors Naushad Ali and Gulam Mohammad, poets Sahir

India – a different perspective

Ludhiyanvi, Jigar Muradabadi, Hasrat Jaipuri and Kaifi Azmi and film director Kamal Amrohi etc. and many more people, were Muslims and worked alongside people from other religions, without even thinking once about the religion. Besides Muslims, people from Christian, Sikh, Jew, and Hindu communities also work in every industry. There are marriages between Hindus, Muslims, and Christians among others all over the country. Does it happen when you do not like or respect others' religion or hate others' religion?

Cricket in India is like soccer in Brazil or baseball in the USA or ice hockey in Canada. People are diehard fans of cricket and cricketers. They are glued to the TV screen, stadiums are full, and those who are on the move listen to the live commentary. Are all the players in Indian cricket teams from one religion or people from one religion watch the matches? The players, captains, coaches, managers from various religions have led Indian cricket teams. This is true for all other sports and games, too. India's

India – a different perspective

national sport is field hockey. The players, captains, coaches, and managers are not from one religion. The selection of players or any person for any other job is not done, based on the religion of the person in India. People are selected, based on their merit and not on their religion.

Despite all this, the media tells the rest of the word that India has religious tension and Westerners usually believe it.

India – a different perspective

Sati

The stories behind *Sati* (self-immolation of a widow) appears to be very ancient. I was told the stories from the past that the widow, who truly loved her husband, acquires some supernatural powers. And if she did not want to live without her husband in this materialistic world, she was able to ignite a pyre (*chita*) by praying to the Fire God. Sati was not burning a lady alive by others. Burning a live person, whether a man or a woman, was and is a heinous crime in India.

Then came the Muslim period in which, let alone a widow, no lady or girl was safe. The queen of Chittor (Rajasthan), *Rani Padmavati* (D. 1330) (*"rani"* means Queen), wife of King Rawal Ratan Singh along with rest all the ladies had jumped into a pyre (called *Jauhar* which means self-immolation instead of being molested i.e., dying with respect instead of living in dishonor) when their husbands had gone to fight with Alauddin Kilji (1253-1282) knowing very well that they

could not win against his huge army. What did Alauddin Kilji want—Chittor? No. He wanted the ladies of Chittor for his Harem.

Similarly, another queen from Chittor, Rajasthan, Queen Karnavati (D. March 08, 1535), who was married to Rana Sangram Singh (Rana Sanga), self-immolated (committed *Jauhar*) along with others to save their honor from the attacks of Bahadur Shah, the ruler of Gujarat. It may be clarified here that *Jauhar* is different from sati. The former means an act of exemplary bravery to protect one's respect while the husband is alive, and the latter means an intense longing to follow husband in death as in life (even death cannot part). Both were voluntary and individualistic in nature and cannot be enforced upon in the past. Now it is banned by law.

A huge fire was lit in a well and all the women of Chittor, following the Queen Padmavati, jumped into the well. Why did these ladies jump into the well? Were they all insane? Did they not feel the

India – a different perspective

pain of being burned alive? Were they not aware of the pain of burning? These ladies jumped into the well to protect their womanhood and self-respect. Was there not an alternative available to these ladies? Yes. An alternative is always available. What was that alternative? Being molested and raped by the Muslim rulers, and their privileged officials and living in their harem as their mistresses for the rest of their lives. These ladies made a choice of dying over being humiliated.

It was during this period when ladies in some parts of India, which was ruled by the Muslims, started embracing death, along with their deceased husbands during the cremation. This practice was primarily to save themselves from the indignities of the Muslim rulers. Now, this is being called the tradition of Sati in India, but is it the Indian tradition? This practice was stopped long ago, and it is a crime in India.

However, in present-day India, whenever a widow does this for the reasons, medical

India – a different perspective

conditions, and the circumstances better known to her, the international media makes it a huge news item, as if every widow burns herself or is forced to be burned along with her deceased husband in India. This does not happen even once every year in India, but whenever it happens, it is shown as if it is happening every day in every home in India. Also, remember there are huge variations in everything in India. On one side, there are people who live in their own world and are called tribal people and, on the other side, are people who lead a life available to only a few elites in developed countries.

Western media publish these stories without finding out the facts and evaluating any real substance. It becomes just a news item, like a natural disaster, where no one knows why it has happened, who are actually affected, and what needs to be done to avoid its repetition.

Sati was a suicide then and, even today, it is treated as a suicide. I am not supporting suicide,

India – a different perspective

but someone has to go beyond the obvious. Why does someone commit suicide?

Journalists must try to investigate and publish the reasons behind this, the mental stability, medical conditions, and the circumstances, which lead to this gross act of violence on one's own body. I might be wrong, but I do not think that a human being can harm his or her body in the normal state of mind. I always find journalists across the world becoming interested in publishing stories of *Sati* as the *culture* of India, instead of exploring the real reason behind suicides by few ladies, once in a while by self- immolation. Do people in other parts of the world not commit suicide? When there is a suicide in any country, do international media publish it as the cultural thing of the country or that race? Why do media discriminate on the method of committing suicide? A suicide is a suicide—whether it is by burning oneself, shooting oneself in the head, jumping from an overpass, or swallowing sleeping pills. Does the

crime become less important or less serious because of the method of committing suicide?

When I refer to the Hindu religious books like *Ramayan* and *Mahabharat*, which are believed to be the true stories from many thousands of years in the past, I find, there was no such tradition. When the king of Ayodhya, Dushrath, died, none of his queens (Kaushaliya, Kaikeyi, and Sumitra) burned themselves. When the King of Hasthinapur died, his wife, Kunti did not burn herself.

Maharani Laxmi Bai ruled the state of Jhansi (Uttar Pradesh) after the death of her husband in 1853. Somebody may come up with the argument that these are all blue-bloods and there was a difference in "common" persons' lives. I believe that the people at the top set the traditions. Generally, common people try to emulate what people in the ruler community are doing. Rani Padmavati did not order or ask others to jump into the fire first. Others followed her. However, there are numerous incidents in

history where the ladies lived, worked, and led normal lives after the death of their husbands. Therefore, I have a hard time reconciling the origin of this so-called Indian tradition as a culture. It is my firm belief that this practice started during the period of Muslim rule to protect the self-respect of a Hindu lady after the death of her husband.

Secularism

India is a multicultural secular country where people from many religions, beliefs, and faiths live and work together. Constitution of India does not discriminate people on the basis of caste, color, gender or religion.

People from various religious beliefs can be seen working together in every public office. People from every religion participated in the struggle for India's independence. They joined Indian Nation Army (*Azad Hind Fauj*) of Subhas Chandra Bose. Indian National Congress (INC) was formed on December 28, 1885, by a British Civil Servant A. O. Hume (Allan Octavian Hume–June 06, 1829–July 31, 1912, who started his service in India at Etawah, a District in Uttar Pradesh), primarily to invite representatives of people of India for talking to foreign rulers for a political solution for a peaceful exit from India. Leaders representing people of India from various religious beliefs have worked together in INC during the struggle

of India's independents. These leaders who were part of Indian National Congress in securing the independence from foreigners after many years of discussions, negotiations and sacrifices were not from one religion. After the independence in 1947, there were views expressed by Mahatma Gandhi and other leaders that Congress should be dissolved as it has served its purpose and political parties should choose new names for forwarding their political agenda in independent India. However, since Congress (Indian National Congress) was a well-known name, a group of political leaders strategically chose to use this name as a political party in independent India.

Shyama Prasad Mukherjee – Vice-Chancellor of the University of Calcutta, and son of Chief Justice Sir Ashutosh Mukherjee, who served as a cabinet minister under the leadership of Pt. Jawaharlal Nehru, later on, formed Bhartiya Jan Sangh (BJS) on October 21, 1951, in Delhi. BJS existed from 1951 to 1980. It was then renamed

India – a different perspective

as Bharatiya Janata Party (BJP), which is one of the largest political parties in India now.

The INC faced a challenge on leadership after the death of Lal Bahadur Shastri in 1967. It split in 1969 forming Congress (O) – for original/old and Congress (R) for Mrs. Indira Gandhi's Ruling Congress. The Congress (R) was split again in 1977 after the first defeat in the history of Congress since the independence of India. Mrs. Indira Gandhi formed a new party Congress-I (I– for Indira), in 1978.

Both of these parties are secular but for some reasons, BJP has been portrayed as a religion based/communal political party of India by the media. BJP (earlier BJS) has followed the principles of Mahatma Gandhi of putting the interests of India, first. They have focused on the idea of popularizing svadeshi things which means made in the own country ("sva" means self/own and *"deshi"* means belonging to a country) without any consideration of caste and religion of the manufacturers. But it has been

translated and conveyed as protecting the Hindus. I fail to understand the translation of "made in own country" as protecting "Hindus" or "being communal or religious" whereas many items are produced or manufactured by non-Hindus. Just to name a few, the majority of the carpet weavers of Kashmir, brass workers of Moradabad, manufacturers, and workers of fireworks and the workers in the leather industry are not Hindus. But promoting "made in own country" (made in India) has been translated and still being translated as "communal/religious."

Let us assume for a minute that BJP is a communal political party and juxtapose a few other facts to analyze this hypothesis.
1. BJP is a pro-Hindu political party.
2. Majority of Hindus in India is undisputable even though it is a secular country and
3. There was communal tension in India due to partition since independence.

India – a different perspective

Ask yourself why did BJP (or BJS) never win a single election in the majority until date? Or Why did BJP (then BJS) never win a single election in the first 30 years since independence, when the concentration of Hindu population was even more?

The very first government formed by BJP (then BJS), as a coalition partner of Janata Party, was in 1977, after 30 years of undisputed majority rule of Congress Party. The primary reason for this win was not its great popularity but a strong anti-Congress Party wave due to the imposition of unconstitutional emergency by the Congress Party leader and the then Prime Minister Mrs. Indira Gandhi (November 19, 1917- October 31, 1984) for political gain.

There was no need for imposing an emergency in the biggest democracy in the world. There was no natural disaster or war or pandemic or any other catastrophic circumstances which would have justified the imposition of a national emergency. It was imposed by her to defeat the

consequences of the Allahabad High Court ruling against her in an election case. The majority of Hindus have voted for Congress/Congress (R)/Congress(I) in most of the elections and given them a majority on the floor of India's parliament. BJP formed a government in 1998 too, but again as a coalition partner under a new banner of National Democratic Alliance and remain in power up until 2004.

Now examine another incident of the nomination of a president during the period when BJP was in power (1999~2004) and decide if the party is really communal. BJP had nominated Dr. A. P. J. Abdul Kalam (Avul Pakir Jainulabdeen Abdul Kalam) for the prestigious post of the President of India. Why would a "pro-Hindu" political party in power nominate and elect the president of India from Muslim community? If the party is against other religions, BJP would never have nominated Dr. APJ Abdul Kalam for the prestigious post of the President of India.

India – a different perspective

There are people, both male, and female, in BJP from various religious backgrounds, and some holding very important portfolio within the party. But media continues to project before common men, an inaccurate, one-sided, and a biased view about BJP for the reasons best known to them, be it a time of elections or any other time, and International media, without ascertaining the truth, simply acts like a highly efficient supercomputer in transmitting these views with lightning speed to the masses in the West.

I do not think that, in a vastly diverse and multicultural country like India, any political party can afford not to be secular. People of India believe in living together happily with people of other religious beliefs. Schools, colleges, government offices, and the highest office have people from different religious beliefs working together all the time.

Sex

Sex is generally perceived as taboo in the Indian context. I would hope it becomes a taboo in India for next few decades at least among 80 percent of the population and the citizens of India so that they would stop indulging in sex. This would greatly help India control the population explosion, which is increasing at an alarming rate.

Had sex been a taboo in India, India would have neither become the most populated country in the world not would she be growing by leaps and bounds. There are temples full of carvings with sexual postures. The Sun temple of Konark (Orissa), built by the Eastern Ganga Dynasty King Narsimhadev (1236 AD–1264 AD), and that of Khajuraho (Madhya Pradesh), built by the King Chandra Varman, the founder of Chandel Dynasty between 950 AD and 1050 AD; depicting erotica in stone is a masterpiece of art and architectural grandeur. I believe this art was created to provide sex education. Moreover, Sage Vatsayan has written a lengthy

treatise, Kamsutra ("Kam" means sex and "sutra" means rule; the last "a" is not pronounced), for those who wished to explore the science and art of sex. What does it tell? Sex is sacred, and it is worth worshiping. People have the wrong notion about the way sex is discussed or talked about in India. Yes, it is considered indecent, rude, impolite, and cheap to talk about sex in public. This does not mean that people do not talk about sex or have sex. It is considered illegitimate between two people if they are unmarried or not married to each other. It is considered vulgar and inappropriate in India to talk about sex education before young children in elementary/primary schools. However, age-appropriate sex education is given in later years in schools in India.

Bedroom scenes and smooching in movies was not considered appropriate in the Indian film industry about a decade or two back in the Indian context, though younger generations of film producers, directors, and story writers, who are out to mint money and vitiate the

India – a different perspective

atmosphere of the society are trying really hard, in the name of art, freedom of expression, or the demand of the story to ape this unique feature from Hollywood films (which may be a part and parcel of North American social fabric) without realizing the long-term consequences on the fabric of the society in India.

It is a pluralistic society with a history of many thousands of years. Everyone knows everyone in the villages or small towns. Sex is left to the married couple. Does it mean there is no prostitute or pimp? No, these things exist in every part of the world, just as homosexuals have existed in all ages. I do not think any individual likes his or her partner having sex with many partners. Do you like your spouse or your parents having sex with multiple partners? Is it something to be proud of or to boast about of having sex with multiple partners?

The so-called free sexual society has amplified a lot of medical issues, and now people are talking about safe sex in western countries. Why

not address the root cause of the issue? Why not treat the root cause of the problem, rather than the effects of the problem? Why not educate people on the benefits of having sex only with one person, and that too, only after tying the nuptial knot?

Encouraging sex among teenagers has its long-lasting consequences on both the mother and the child. Promoting the concept of a single mother sounds revolutionary, but parenting is not about a revolution. It is about caring and providing society with someone who can be a good global citizen. Why do so many people talk about the importance of parents in the life of a child? Is it normal for the majority of these children to be raised by single parents in their development? Do they not have psychological problems later in life? Do these children not tend to become individualistic in their attitude with little care about the society, social life and the people around them because of their upbringing under artificial atmosphere during the impressionable years? Do they develop feelings

of love, kindness, and compassion towards their fellow human beings? Do they have a charitable disposition? Do they entertain any feeling of extending help or assistance to a person in distress? Do these children develop the same family and social values which are found in a child who is raised under the love, care, and protection of a full family and gets love and affection from a number of relations and neighbors? The concept of a single parent may satisfy the ego of an individual, but it makes the child develop an "I, me and myself" philosophy which weakness, shakes and digs the very foundation of a healthy and vibrant society as an institution. Well, metros in India are aping this culture blindly, but the rest of India is backward if this is progress. Nevertheless, sex was and is known in India and has a different paradigm, but it is deemed as not a taboo.

India – a different perspective

Snake Charmers

Indians love for every living species including birds, animals and plants in the world. They have been taught to live in harmony with them because they too have a life. That is why every god or goddess has a bird or an animal in his company and utilized as a vehicle for their transport. Indians love every species of animal in the world. They have been taught to live in harmony with the rest of the species. Many animals are considered as transport vehicles or the pet of a god or a goddess. There are three main Gods in the Indian mythology: Brahma, the god of creation; Vishnu, the god of providing earthly comforts; and Mahesh, the god of destruction. It is said that, in an attempt to avoid the spilling of the poison ("*halahal*" which was, as per mythology, one of the fourteen items churned out of the ocean) into the ocean, which could have polluted the entire world and perhaps killed many species living in the ocean, Lord Shankar (another name for Mahesh, the god of destruction), held it in his throat for a very

India – a different perspective

long time but did not swallow it. Had he swallowed it, he too would have died. In the process of keeping it in this throat, his throat turned blue and hence he is also known as *Neel-kunth* ("*neel-kunth*" means "someone with blue throat"; "neel" means blue and "kunth" means throat). After that, he became associated with snakes and snakes are considered his pets.

Therefore, the snake is considered a friend of someone who is extremely powerful and has the power of destroying the world. Can one afford to be an enemy of someone whose friend is known as "terminator of the world?"

There is a tribe, negligible in numbers, who captures and keeps snakes as pets. They collect snake venom and give it for medicinal purposes. The people from this tribe are called "*sapere*" (*sapera* is singular) and have been referred to as "snake charmers". It is also said that these people have the skills to remove the venom from the body of a person who has been bitten by snake through some *mantra*s and

rituals. *The mantra* is a Sanskrit word, which means a phrase of a few words and meant for silent recitation. These secret *mantra*s and rituals are passed on from father to son. There are stories that the people from *sapera* community are able to revive the people, who had died from snake bite. The famous Hindi short story writer, Munshi Premchand (July 31, 1880–October 08, 1936) has written one such story titled Mantra. It is a story about the altruism of a person from the *Sapera* community, whose sick son was even refused to be seen by a doctor, and soon his son died. Later on, the same *sapera* revived that doctor's son who was bitten by a snake by removing the poison from the dead body of his son through *mantra* and rituals.

The *Sapere* bring snakes for showing to people, like a mobile reptile zoo. In return, people offer them money/food/clothes. These people are also invited for capturing snakes from people's homes in rural/urban areas. There is a festival called *Nag Panchami* ("*Nag*" means snake and

India – a different perspective

"*Panchami*" means the fifth day of a fortnight). It is celebrated in July/August (during the moonlit phase of *Savan*). The *Sapere* come with snakes on this day and people specially offer milk to the snakes. Since snake is associated with Lord Shiv, *Sapare* also come on *Shivratri* day. It is celebrated in February/March (on the 14th day of the moonless phase of *Phalgun*). That is why people in India do not generally kill snakes. Besides, Indians are a large farming community. Rodents are bad for crops. Snakes eat and scare rodents. It is a known fact that there are very few species of snakes that are poisonous. Medicines prepared from their poison is used in treating many illnesses, too, which is another reason for not killing snakes. However, one does not find people from this community in urban areas nowadays.

Students in School

Corporal punishment in schools and boarding schools is a punishable crime in India. Students are not supposed to be touched in the schools in India. There are parent groups and many other organizations, which oversee that students are not physically harmed.

But the perception that students are beaten and touched continues. So, where did this "view" come from? It comes from missionary schools—Christian and Muslim—where caning was in practice during the British and Muslim periods and continued after Independence, too, in spite of a ban by the law. Does it still continue? To the best of my experience, it has stopped. Again, as I said before, people follow the ways of authority. The caning of the students was a norm in the schools run by Christian missionaries and Muslims during the period of their rule. They followed the principle of "spare the rod and spoil the child". And this was not for a short period of time and continued for

hundreds of years. Generations have seen this type of schooling and suffered from it. These people, when they grew up, behaved in the ways they were treated, considering it to be a normal way of teaching, knowing it is inhuman. This practice is now punishable under the law.

Most of the schools now have a very different environment than that of the missionary schools. Physical punishment in today's modern schools in India is unheard of. But there is always an odd teacher carrying "the genes" from hundreds of years of slavery under the Muslim and British rule, who got educated under those conditions where students were meted out this treatment. It is teachers like these who make front page news by treating students this way without any remorse and thus tarnish the image of India. They forget that now they are living in independent India, where it is frowned upon. This is certainly not a part of the Indian culture of imparting education.

India – a different perspective

In ancient times, the life of a person is spread over four stages called *ashram* alluding to a "stage of life". The literal meaning of *ashram* is a place to live. These *ashram*(s) are *Brahmacharya* (celibacy), *Grahasth* (family), *Vanprasth* (retired from active family life), and *Sunyas* (sainthood). Each *ashram* is supposed to be for twenty-five years, considering the total lifespan of a normal person to be of one hundred years. *Brahmacharya Ashram* is the first quarter in the life of a person, which includes the student period. A person is supposed to devote oneself to learning and practice celibacy during this stage. Children were sent to the place of learning called *Gurukul,* which means the place of *guru* (teacher) during this stage. The second quarter is the *Grahasth Ashram*, which involves raising a family. This also ties up with my conclusions under "Child Marriage" that there was no concept of child marriage in ancient Indian society and a person used to get married in the twenties. The third quarter is *Vanprasth Ashram* in which a person is supposed to withdraw oneself slowly from the day to day

India – a different perspective

affairs of the family and allow the next generation to shoulder the responsibilities of their families for the next twenty-five years. The last stage is *Sunyas Ashram*, which means a person is to detach oneself from the earthly attractions, to start living like a hermit, and to focus on praying to God.

As far as the education is concerned, the children aged about eight to ten years went to a *gurukul*. There they lived, grew up, and learned various subjects from the *guru* for an extended period of time, which may be ten to fifteen years. The *guru* and his family treated all the students equally. The students were considered to be an extension of *guru*'s family. The wife of the *guru* addressed as *guru-mata* (*mata* is a Hindi word derived from Sunskrit word *matra* and both mean mother) also taught many skills and crafts to the students. The physical harm in the Indian ancient traditional education system was unheard of. Students, once their education was completed, left for their homes to start next phase of their lives.

Talent Pool

Indians are out-performing in many international exams. They are at the top positions in almost every field in the world, but the media do not feel shy in publicizing the idea that India has a lack of a talent pool with managerial capability. I listened to one such news in North America as late as in 2011. Indian Institutes of Technology (IITs) have been bringing out fine engineers for about the last five decades and providing them to the USA, Canada, and many developed countries, despite the lack of a talent pool in India. Indian Institutes of Management (IIMs) had been producing MBAs to the world, despite the shortage of a talent pool in India.

Let me pose a simple question. When do you export anything—when you have a shortage or an abundance? When do you import anything—when you have a shortage or an abundance? If India is consistently providing fine-quality engineers, scientists, and MBAs to the USA,

India – a different perspective

Canada, and to the rest of developed world, does India lack a talent pool?

Look at the top jobs in the USA—both in private and public sectors—be it NASA, Silicon Valley, the financial sector, healthcare, or education. Do you not see people of Indian origin at the top? The training and education system in India has very strong fundamentals and focuses on polishing the students to the extent that all the students, by the time they complete their program, become useful gems.

The process of entrance in any program is so tough that people in North America cannot even imagine it. It is like keeping the funnel inverted for collecting rainwater and selecting the people who successfully fall through the smaller tube. Besides, there is an age limit for doing a course. This provides fair competition to all, unlike in North America where a twenty-five-year-old competes with those fifty-two years young for the same program or jobs.

India – a different perspective

I do not have any statistics to prove this point, but my informal survey among families and friends support my view that the children who have completed their primary education in India do far better in universities, higher education, and professional education, and later in careers in North America, than their counterparts who have completed their entire education in North America.

Still, people trust and believe the surveys published about the lack of a talent pool in India? I do not think so. I think what Indians lack are the opportunities within India for the abundant talent and fair opinions about the true issues in India from international journalists and the media.

India – a different perspective

Untouchables

As far as untouchability is concerned, it has been practiced all over the world since ancient times for various reasons. One such reason is the fear of catching infections and contagious diseases. This fear prompted the people to isolate people suffering from such diseases from mixing in the society, irrespective of their race, caste, color, religion, profession, or sex. It mattered little if they were young or old, male or female, their kith and kin, or friends.

Leprosy was one such dreaded disease. Those who have seen the movie *Ben-Hur* (1959) will recall the scene depicting a lepers' colony. This goes to establish the practice of *untouchability* during the Roman Empire. Then, there was a time when people avoided contact with those suffering from tuberculosis, smallpox, or malaria.

Poet John Keat's (October 31, 1795– February 23, 1821) proposal for marriage was rejected

because he was said to have tuberculosis. Such people were kept in isolation. Now, every hospital dealing with the infectious disease has an isolation ward. In the present day, it is common knowledge that people keep a distance from those who have any viral infection. The word "quarantine" as defined by the *Oxford Dictionary* means "a state, period, or place of isolation for people or animals that have arrived from elsewhere or been exposed to contagious disease." It is worthwhile to observe, here, that even animals have not been spared.

The second reason to avoid close contact was the nature of work or the working conditions. People avoided those who were involved in doing unhygienic work or working under unhygienic conditions, like sweepers, scavengers, gravediggers, or those who skinned dead animals and collectors, undertakers, and those who did mummification.

Many may remember that there was another movie, *Land of The Pharaohs* (1955), which

depicted a scene in detail about the professional precision with which the dead bodies were turned into mummies and carried away for burial. The third reason was a transgression of moral laws, which made such a person an outcast. Finally, there is Apartheid, which means segregation on the grounds of race, which was present in Africa from 1948 to 1994, and it was also a form of untouchability. Therefore, it can be said that untouchability was practiced in one form or the other across the world.

As for untouchability, as such, in India, the first thing to be kept in mind is that the word "untouchability" is not mentioned in *Manu Smriti*, since a *Shudra* is worthy of honor because of his age (*Manu Smriti II*, 137, 155), the *Shudra* wife of a teacher is given due respect (*Manu Smriti II*, 210); a *Shudra* can be a teacher and a pupil (*Manu Smriti III*, 156); a *Shudra* can be a witness (*Manu Smriti VIII*, 63), and he can give evidence (*Manu Smriti VIII*, 68). This shows that *Shudra* did not ipso-facto mean untouchables.

India – a different perspective

Further, a mention in *Manu Smriti* is made of the forbidden occupation of a seller of leather products, meat, butchers, and publicans, but they have not been categorized as untouchables. Similarly, outcasts have been mentioned, but these are those who have transgressed some social or moral laws of the time. However, only an individual is made an outcast and not the whole community of people. Moreover, once the atonement or penance is done, the person is accepted back. So, they also do not form a class of untouchables.

It may be worthwhile to share that *Shudra*s fought side-by-side with other castes, during the first war of independence in 1857, which the British derided as "mutiny," as well as during the non-violent freedom movement under the leadership of Mahatma Gandhi. Here, I should clarify the *Mahatma* is a title which means "great soul" (saint) and it is not his first name. His full name is Mohandas Karamchand Gandhi.

India – a different perspective

The freedom fighter, tribal leader Birsa Munda (1875–1900) of Bihar, fought against the British and made the supreme sacrifice of his life. Patriotism is not the monopoly of any particular caste or creed or race.

Only those were considered as untouchables, who became associated with unhygienic work, which formed a very small section of the society.

Secondly, it is my considered view that the concept of untouchability in the *Shudra* category is of late origin; that is, the effect of Muslim rule. People started avoiding even those who became friendly with the Muslims. However, untouchability was outlawed in India with the enforcement of the constitution of India on January 26, 1950, making them a part of the mainstream. Further, it may be kept in mind that a period of seventy years in the life of a nation is too short to usher in drastic changes, bring about overnight changes in the mindset of people, and produce miracles. The wheel of social change moves rather slowly. But an

overall change is perceptible, though it may take the time to produce the desired visible changes.

The *Shudra* community had been deliberately projected as untouchables for political gains. They worked for all the sections of the people in the society. They used to work on farms and inside the houses. They had equally important roles to play in the society. These people had enormous physical strength and endurance for working long hours.

Now, all those who were called untouchables, have become a part of the mainstream. They get an education of their choice, join the profession of their choice, and mix with other people. However, as against the lifespan of a person, the sixty-odd years' period of independence is too short in the life of a society to produce miracles. It is hoped the day will come when they will be fully assimilated into the society, and sporadic cases of discrimination against them in the hinterlands will become a part of the history.

India – a different perspective

In the epic *Ramayan*, Lord Ram ate berries from the hands of a devotee Shrabari, which were first tasted by her to ensure the sweetness of each berry. Shrabari was from the *Shudra* community. The boatman in whose boat Lord Ram crossed the river was, like Shrabari, also not from the upper caste.

Later from the period of Mahabharat, Lord Krishna preferred to partake a simple food at the house of Vidur, the son of a maidservant, rather than dine in luxury at the palace of Prince Duryodhan. The treaties of judicious actions by Vidur, known as *Vidur Neeti* (Treaties of Vidur, *neeti* means treaties), like the treatise on diplomacy by Chanakya (*Chanakya Neeti*) and on the economy (*Arthashastra*), speak volumes on his learning because, whereas Chanakya was a *Brahman*, Vidur was not. King Chandragupt Maurya, who was made king by Chanakya, was also not from an upper caste. All this shows that *Shudra*s were not untouchables until quite late.

India – a different perspective

The sage Ved Vyas, who wrote *Srimad Bhagvat* and other treaties was the son of a *Brahman* sage Maharshi Parashar and Satyavati, the daughter of a boatman. Similarly, Akshamala was united to sage Vasistha, and Sarangi was united to sage Mandapala (Manu Smriti IX, 23).

Do you still believe that India really has the problem of untouchability or that it was created for some gains[18] and is still being used as a strategy for the politics of votes in elections?

18 Sudras in Ancient India by Ram Sharan Sharma, 1990, Motilal Banarsidass Publisher Pvt. Ltd. Delhi

India – a different perspective

Women in the Workforce

It is almost a firm belief that there is a negligible number of women in the workforce in India. That, women in India are not given chance to work with their male counterparts. There are two things to be addressed, and the first point is the most important—working in a corporate office or in an organization is not the only way of participation in raising the family or supporting the family in India. The women, who spend time at home taking care of household work, are considered equally important in Indian society and the least important is equality through working with men. Women in rural India have been participating in farming activities equally with men for centuries, yet they are not considered as working women because these women do not bring cash and to be a part of a workforce one must bring cash. So, assisting in farming/business activities and/or attending to household work, is taken as a part of family duty. I am not aware of any attempt made to evaluate, assess or measure women's

contribution in terms of earnings on the basis of time spent on each of these activities. An example will make the point clear. Is a housewife doing household chores (like sweeping, cleaning, washing, cooking, sewing, darning, knitting, babysitting, etc.) not earning, in terms of service, an equivalent of what is given to a service provider? It will throw up interesting statistics about the contribution of housewives in running a family on shoestring budget.

According to 2001 census of India, 127 million women were in the workforce, which accounts for about one-third of the total workforce[19] (Table 1). Compare this with USA statistics in 2000 and you will still find a difference of 8 percent between male and female workers in the total workforce (Table 2). The difference in employment between genders in Canada is 6 percent (Table 3).

19 http://www.censusindia.net

India – a different perspective

Table 1: Workforce by gender in India (2001)

Total	Number	Percentage
Males	275,014,476	68%
Females	127,220,248	32%
Total	**402,234,724**	**100%**

Table 2: Workforce by gender in the USA (2000)

Total	Number	Percentage
Males	74,273,203	54%
Females	64,547,732	46%
Total	**138,820,935**	**100%**

Table 3: Workforce by gender in Canada (2000)

Total	Number	Percentage
Males	9,021,300	53%
Females	8,104,500	47%
Total	**17,125,800**	**100%**

It is also important to know that ratio of male to female in India in 15-64 years of age group is 1.07 whereas this ratio in the USA in the same age group is one i.e., India's male population in the age group of 15-64 years is 4% more than the female population in the same age group but

India – a different perspective

the difference in population between male and female in this age group in the USA is zero[20].

The second very important thing to remember is that women in the USA and Canada do not have the choice of *not working* and pulling the family with a single income. In India, the majority of families live a decent life with a single income. In the USA and Canada, the cost of living is much higher, as compared to the cost of living in India. This is very shocking when you top it with so-called free medical and free education. The families who earn single incomes in India provide education to their children in private schools and afford private medical services. The superb quality of these services is beyond comprehension for those who have not experienced it first hand in India.

Almost all of my known families of relatives and friends are single income families and they maintain maids too. The lady of the house has many things to manage, including taking care of

20 www.cia.gov/library/publications/the-world-factbook; 2011 estimate

the children. The concept of leaving the children at the disposal of a babysitter or a caretaker is yet to be picked up, even in metro cities. It is the cultural belief that parents take care of the children' interest the best, which no one else can do for any amount of money. Moreover, instances have come where babysitters or caretakers have misused their position or neglected their responsibilities.

Taking care of the household affairs by the lady of the house is by no means a small job. This includes dropping the children at school and picking them up after the school, teaching the children after school, helping them with their homework and other project work, providing them training for cooking, sewing, knitting, etc. These ladies are highly educated, which helps them in managing the budget for the home expenses.

The trend in metros and big cities is changing. The younger generation does not consider these activities as valuable, and they are

India – a different perspective

aspiring and engaging more and more for corporate jobs.

Why working in an office is more important than working at home or on a farm?

Women's Privileges

I think India is the only country and Hinduism is the only religion where goddesses are worshiped. A wife is considered an equal partner in the life of a man. Both man and woman are considered as two wheels of the cart to carry on the journey of life.

The festival of *Rakshabandhan* and *Bhai-Dooj* (as explained under the Female Children's Privileges) is also celebrated by adult women. The brother, in turn, offers clothes, sweets, and money with a promise to protect her.

I remember reading somewhere decades back that "if one were to survey God's cabinet in the Hindu Pantheon what one finds is" that "all the important portfolios in the Divine Cabinet are held by women: finance is held by Goddess Lakshmi; education is held by Goddess Sarasvati; and defense by Goddess Durga." Yet the women in India are portrayed as

underprivileged by the media and believed by the Westerners. How unrealistic!

This is not something new, due to a women's right revolution group or a legislation by the United Nations; it has been in practice for thousands of years across India—both in urban as well as in rural areas.

Now, let us scan the Indian scene about the role of privileges to Indian women. In ancient India, we had Ahilya (wife of Sage Gautam), Draupadi (wife of Arjun), Mandodari (wife of Ravan, King of Lanka), Sita (wife of Lord Ram), and Tara (wife of King Harishchandra)—all married women who rose to the celestial state and are remembered during weddings. Queen Kaikeyi, the third and the favorite wife of King Dashrath of Ayodhya (Uttar Pradesh) and Stepmother of Lord Ram, accompanied her husband to the battlefield and earned two boons from him for helping him on the battlefield.

India – a different perspective

Queen Naika Devi was the daughter of Paramardan (Shivchitta) of Kadamba dynasty. She ruled Gujarat as Queen Regent (1176–1178) and commanded the army. She fought Muhammad Ghori (1150–1206) and defeated him in 1178. Muhammad Ghori's army suffered heavy casualties in the battle in village Kayadara near Mount Abu (Gujarat) and retreated back across the desert to Multan and he never returned to Gujarat.

India is the only country in the world which got a large number of women rulers such as Queen Durgavati (1524-1564) of Gadhaha, Madhya Pradesh (during Akbar's rule), Queen Chennamma (1778-1829) of Kittur, Karnatak (a contemporary of Tippu Sultan), Queen Ahliyabai Holkar (1725-1795) of Indore, Madhya Pradesh, Queen Lakshmibai (1835-1858) of Jhansi, Uttar Pradesh, Gond Queen Avantibai (D.1858) of Garha Mandla, Madhya Pradesh, Queen Ishwori Kumari Devi of Tulsipur, Uttar Pradesh, Queen Avantika Bai (D.1858) of Ramgrah, Madhya Pradesh, and Queen Baijabai Shinde

(D.1862) of Gwalior, Madhya Pradesh, who was one of the Founder Members of the War Council which led the War of Independence of 1857. Queen Karnavati was another brave and famous queen, who took up the reins of the State after the death of her husband in 1631. Her husband Mahipal Shah ruled Garhval, Uttarakhand from 1622 to 1631. She consolidated the State by fighting very bravely with the invaders and the Mughal army led by Najabat Khan in 1640 and defeated both of them. She earned the nickname of *Naak Kaati Rani* (the queen who cuts off nose; *naak* means nose, *kaati* means to cut off, and *rani* means queen) because of slashing the noses of the invaders to deter them from approaching again. She was responsible for constructing Rajpur Canal, one of the many in the district.

Looking closer, we find women who have shown exemplary fortitude when needed. In the Indian National Army (Azad Hind Fauz) of Netaji Subhash Chandra Bose, Dr. Lakshumiyah was

India – a different perspective

on the civil side of the INA Organization[21]. Dr. (Mrs.) Lakshmi (Swaminathan) Sahgal, who married Captain Prem Kumar Sahgal of INA, was Commandant of *Rani of Jhansi Regiment*[22]. She was born in Madras in 1915 and died in Kanpur in 2012 where she had settled down and was running a maternity clinic. Durga Devi (also referred to as Durga Bhabhi) provided active help to the revolutionary group of young Indians in the 1940s against foreign rule.

India produced many saint-poetesses like Meera Bai (1498–1547) of Marvar (Rajasthan), and Lalleshvari (1320–1392) of Kashmir and many women saints like *Mata* (Mother) Roop Bhawani (1621–1721), Bahinabai (1628–1700) of Maharashtra, Mrs. Mathura Devi (Kaul) Kandroo (1878–1985), Mrs. Bhawani Pandit (1897–1972), Mrs. Mata Shri Radhamali (Kaul) Raina (1890–1952), Mrs. Kalavati (Kaul) Kachroo (1907–1998), Mrs. Vanumali (Bhatt) Kothedar (1909–1998), Yogini Sharika Sopori

21 Page-40; Story of INA by S. A. Ayer, National Book Trust, 2006
22 Page 46; Story of INA by S. A. Ayer, National Book Trust, 2006

India – a different perspective

(1913–1991), Karunamai Ma, Mrs. Vimla (Kitchlu) Channa (1913–2000), Mata Amritanandmai (Birth-Kerala, 1953), Parampujya Ma (1924— 2008), Arpana Ashram, Madhubah, Karnal (Haryana) and Anandamayi Ma (1896–1982).

Women were given the equal opportunity to contribute to the formation of democratically electing the government of Independent India by providing them equal voting rights since independence in 1947 and, with the exception of just a few developed countries, most of the developed countries with so-called equal rights of women never had a woman Head of State until date. Whereas Mrs. Vijay Lakshmi Pandit (August 18, 1900–December 01, 1990) was the first woman cabinet minister, the first woman President, UN General Assembly, and the first woman High Commissioner, UK. Mrs. Indira Gandhi was the first woman Prime Minister during 1965–1977 and again during 1980–1984. She was the second woman Head of Government in the world after Mrs. Srimavo

India – a different perspective

Bandaranaike of Sri Lanka. She was the longest-serving woman prime minister in the world and the first woman Head of Government to be assassinated while in office. Many women have made it to the Parliament in India and the Upper House as members and some even became ministers and speakers of the House. Many women joined state-level political fields and became the members of the Legislative Assembly (MLA), ministers, Chief Ministers (Premier) and Governor. Mrs. Pratibha Devisingh Patil (Birth 1934) who started as a lawyer and rose to become a member of State Assembly, a minister, the leader of the opposition, Chairperson of the Upper House (1985–86), and Governor of Rajasthan (2000–2007) has the distinction of becoming a woman President of India. And it cannot be said that all belonged to the privileged class or came from affluent families. This phenomenon is visible in the entire Indian sub-continent and has been for a long time. Mrs. Sirimavo Bandaranaike, Mrs. Benazir Bhutto, and Mrs. Sheikh Hasina Wazed became Prime Ministers of Sri Lanka in 1965,

India – a different perspective

Pakistan in 1988, and Bangladesh in 1996, respectively. It would be educational for me to know if there have been so many women from developed countries who held these high posts for so long.

In India, unlike in developed countries, the power to women is not given because of their gender or for the purpose of improving the ratings in the United Nations. Women in India, like men, are given an equal chance to compete, and the deserving ones are selected to public offices on the basis of their merits and not because of their gender. Mrs. Mohan Rani Nehru contested the election of Municipal Board, Allahabad as early as in 1912. Mrs. Shanti Bhatt was a member of Municipal Corporation, Lucknow. Mrs. Dhanraj Bakshi was the Chairperson of District Board (*Zila Parishad*), Lucknow. Mrs. Jyothi Reddy was Chairperson of District Board (*Zila Parishad*) Kadapa (Andhra Pradesh). They have become Mayors and won Village Administration

(*Panchayat*) elections and become Heads of Village Administrations (*Pradhan*).

In India, women have excelled in almost every field—be it education, law, the judiciary, medicine, art, culture, and literature, journalism, administrative services, foreign services, law-enforcement services, defense services, or social services. Yet, the irony is that the women in India are portrayed by the media and believed by the majority in the West as underprivileged.

Mrs. Dhanvanti (Handoo) Rama Rau (1893–1987) was the founder and the President of the Family Planning Association of India, as well as the founder and the President of International Planned Parenthood. Mrs. Kiran Bedi, a Ramon Magsaysay Award winner, and a retired Police Officer was the first woman officer of the Indian Police Service (IPS) in 1972, who set the trend for police jobs and, today, there are thousands of women holding different posts in police departments. Women have held the important posts of Cabinet Secretaries, ambassadors,

India – a different perspective

Chairpersons of the Income Tax Department, and the Deputy Governor-Reserve Bank of India (RBI). Dr. Hansa Mehta became the first woman Vice-Chancellor in India at M. S. University, Baroda (Gujarat) in 1949[23]. The trend continues and some of the recent representative holders of this high office are Dr. Hemixaben Rao, Hemchandracharya North Gujarat University, Patan, Gujarat[24] (2011) and Prof. Malabika Sarkar, Presidency University, Kolkata, West Bengal[25] (2011). Many women practice Law, and quite a few have joined the judiciary and have become judges in subordinate courts, high courts, and the supreme court. These women were not concentrated only in metro cities. Justice M. Fathima Beevi (retired) became the first woman judge of the Supreme Court of India in 1989. She was also the first woman judge of a supreme court of a nation in Asia. Some other Supreme Court women Judges are Justice

[23] http://www.msubaroda.ac.in
[24] http://www.ngu.ac.in
[25] http://www.presiuniv.ac.in

India – a different perspective

Ruma Pal, Justice Gyan Sudha Misra and Justice Ranjana Desai.

Women have made a name in the field of games, sports, and athletics. Some of them include Bula Choudhury, who was the first girl to swim across the English Channel; Bachendri Pal liked mountaineering from a very early age and conquered the peaks of Mt. Everest; P.T. Usha won medals in sprint races; Karnam Mallesvari earned medals in weightlifting. Women have also participated and won medals in other sports, like boxing, badminton, etc.

Indian women have participated in the beauty pageants and have successfully competed to make a name in the world of glamor by winning Miss India, Miss World, and Miss Universe titles. Pramila Esther Abraham initiated the trend by becoming the first Miss India in 1947. Reita Faria, a medical student, set the ball rolling in the Miss World pageant by winning the title in 1966 in London (UK). Sushmita Sen, Aishwarya Rai, Lara Dutta, Priyanka Chopra, and Pooja

Batra were other successful beauty queens from India, who won Miss World/Universe awards.

Women have also been in the fields of singing, drama, movies, film direction, etc. Many artists have established milestones in the field of acting and directing in the cinema industry internationally.

Poetesses Dr. Mahadevi Verma and Mrs. Subhadra Kumari Chauhan and prose writers Amrita Pritam, Ismat Chughtai, Mahashveta Devi, Padma Sachdev, Chitra Mudgal, Mridula Garg, and Mamta Kalia are established names in the field of literature.

The above-mentioned names are neither exhaustive nor representative of people from every state. These represent the involvement of women in the fabric of Indian culture and society since ancient times, which continues in every field, even today.

India – a different perspective

Even in the corporate world, women are involved in the highest positions. Here is a sample list of these organizations (in the alphabetical order). Look at these organizations, and guess if all of these are multinational organizations from the Western world or Indian organizations, where women are at the helm of affairs of these organizations in India.

Name	Organization
Meera Sanyal	ABN Amro Bank
Shikha Sharma	Axis Bank
Zia Mody	AZB Partners
Kiran Mazumdar Shaw	Biocon
Vinita Bali	Britannia
Neelam Dhawan	Hewlett-Packard
Naina Lal Kidwai	HSBC India
Shobana Bhartia	HT Media
Chanda Kochhar	ICICI Bank
Lalitha Gupte	ICICI Bank
Shikha Sharma	ICICI Prudential
Renuka Ramnath	ICICI Ventures
Kalpana Morparia	JPMorgan
Nadia Chauhan	Parle Agro

India – a different perspective

Name	Organization
Indra Nooyi	PepsiCo
Mallika Srinivasan	TAFE
Manisha Girotra	UBS
Anuradha Desai	Venkateshwara Hatcheries

The above list becomes longer when it comes to director-level positions and below. This is again something not new. The few names given above are to suggest that women in India have played pivotal roles in the family, business, and society. The list is symbolic only, and I have not tried to put the names of one lady from every region or from every religion or every caste just to be politically correct.

India – a different perspective

Worshiping Plants & Trees

Many people wonder why people in India worship plants and trees. It was well known among Indians that plants and trees have life, as established by physicist turn plant biologist Sir Jagdish Chandra Bose, CSI, CIE, FRS (November 30, 1858—November 23, 1937) and that human beings and plants depend on each other. So, Indian society worshiped and protected plants and trees for providing good crops (prosperity).

There are some scientific reasons, too. The trees or plants that are worshiped have high medicinal value and support the environment. Every home keeps a plant of *Tulsi* (also known as Holy Basil; botanical name – *Ocimum tenuiflorum*) in the middle of a home and/or in front of a home. It is an aromatic plant and produces oxygen at night by absorbing carbon dioxide, which is the opposite of almost all other plants and tree. Its leaves are boiled in water and the water containing the extract of this herb

is very useful in treating the common cold, and fever and acts as a natural analgesic.

Another tree is the Pipal (The Sacred Fig or Bo-Tree), a species of banyan fig. This tree is worshiped because it also produces oxygen at night. Cutting down a Pipal tree is considered ominous, and for this reason, it is conveyed in stories that a ghost and/or a witch will harm the person who cuts this tree. This is simpler to communicate than saying, "Do not cut this tree because it provides oxygen at night," and easier to understand by anyone. There are very few plants that produce oxygen at night. These two plants are found in India and, hence, worshiped.

Plantain/banana trees are worshiped, basically to protect it from being cut, because its leaves are used as plates for eating food besides its fruit is rich in potassium. There are many other big trees like Neem, Banyan, Ashoka (from the family of legume) etc., which are not supposed to be cut.

India – a different perspective

Worshiping and praying was designed to involve the communities in protecting and nurturing these plants so that no one should try to destroy or ignore it. The underlying belief is that trees are good for the environment and human depend on them.

Epilogue

The above discussion was to touch upon some of the important topics I have come across about India and to provide some insights. Every country has its pros and cons and so does India. Now, there is a question that has popped up, that is, despite so many positives, what is preventing India from becoming a developed country. I have started putting together my thoughts on the reasons for India's current status and will be sharing it in due course.

Made in the USA
San Bernardino, CA
12 April 2018